BLACK AMERICA SERIES

ANOTHER
ANN ARBOR

To Nicholas
Continue the legacy

Carol Gibson
&
Lola M Jones
2/07

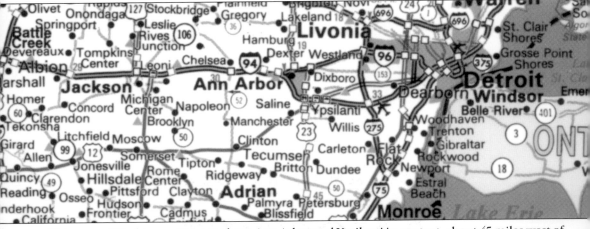

This map of Washtenaw County places Ann Arbor and Ypsilanti in context, about 45 miles west of Detroit, and east of Jackson, Michigan. The University of Michigan was at first located in Detroit, but was later moved to Ann Arbor. In the early days, travel between Detroit and Ann Arbor or Ypsilanti was arduous by wagon or horseback.

On the front cover: This 1946 photograph of tea at the Dunbar Community Center typifies the formal celebrations African American ladies enjoyed at the center. They wore dressy hats and white gloves on these special, social occasions. The table was always arranged with the best silverware and china. Sometimes funds were raised to support important causes. The Dunbar Community Center was named for the renowned African American 19th-century poet Paul Lawrence Dunbar. (Courtesy of Arbor Community Center.)

On the back cover: Sunday school students pose on the steps of Bethel African Methodist Episcopal Church at 632 North Fourth Avenue, Ann Arbor, around the 1930s. (Courtesy of Bethel African Methodist Episcopal Church.)

BLACK AMERICA SERIES

ANOTHER ANN ARBOR

Carol Gibson and Lola M. Jones

ARCADIA
PUBLISHING

Published by Arcadia Publishing
Charleston SC, Chicago IL, Portsmouth NH, San Francisco CA

Printed in the United States of America

Library of Congress Catalog Card Number: 2006920841

For all general information contact Arcadia Publishing at:
Telephone 843-853-2070
Fax 843-853-0044
E-mail sales@arcadiapublishing.com
For customer service and orders:
Toll-Free 1-888-313-2665

Visit us on the Internet at www.arcadiapublishing.com

*We dedicate this book to our husband and dad,
Dr. Lee W. Jones.*

CONTENTS

ACKNOWLEDGMENTS

I have had this book in mind for years. The idea occurred to me in 1989 when Carol and I were producing the documentary *A Woman's Town*. I felt this was a story that had not been recorded, yet needed to be remembered.

Creating this book was a journey we undertook with both joy and apprehension. I made the choice to depict a positive story: of prevailing over slavery, segregation, and discrimination while creating our own institutions and support systems. Our brave pioneers fashioned successful lives, and made social contributions while raising loving families. Their histories are recorded in the archives of our churches, clubs, and organizations, and most importantly, in the memories of our longtime residents.

In telling this story, we were assisted by numerous people: Dr. Larry Gant, professor of social work, University of Michigan; University of Michigan students, Bev Willis, our graphic designer, Negin Salmasi, our photographer; Ann Hampton Hawkins, executive director, the Ann Arbor Community Center; Kay Berklich, the *Ann Arbor News*; Penny Schreiber, the *Ann Arbor Observer*; Bruce Mardej, the University of Michigan Athletic Department; Ben Johnson and Bree Doody, the University Musical Society; the African American Cultural and Historical Museum of Washtenaw County; the staff at the Bentley Historical Library; Gerry Petty, at the Ypsilanti Historical Museum and Archives; Wyston Stevens, Ann Arbor historian; Susan Wineberg, author of *Lost Ann Arbor*; John Behee, author of *Hail to the Victors*; Stacey Henderson, secretary at Bethel African Methodist Episcopal Church; John Woods Jr., William Hampton; Rosemarion Blake; Pauline Dennard; Florida Miller; Robert Hunter; the Ellis family; the Baker family; Coleman Jewett; Mallory Thomas; Shirley Martin; our editor Anna Wilson; and so many others. Thank you all.

Carol thanks her daughter Lola Kristi Gibson-Berg, the Reverend Doctors Mary Clark and Robert Garwig, her Melaleuca team, and Dr. C. We both thank friends and family, especially Dr. Janet Gibson. This book has been a collaboration. We are grateful to all who participated and shared our vision. We hope you will enjoy and relive the sweet memories.

FOREWORD

For much of its history, Ann Arbor, Michigan, has been known as the home of one of the world's preeminent higher education institutions, the University of Michigan. Also, within recent decades it has acquired a reputation as one of the country's most livable cities. Generally, these views of Ann Arbor in the public mind rarely embrace the multiracial and multiethnic history of this vibrant mid-size metropolis.

Lola Jones and Carol Gibson have given us a marvelously insightful corrective to this impression. *Another Ann Arbor* honors its title. It introduces us to a world that has too often been invisible, due to the cultural and social blinders to and barriers erected against it.

Covering a period of time from the 19th century to the present, *Another Ann Arbor* offers us a close up glimpse into the class and institutional structures of African American life in America. The edifices of faith pictured there, the entrepreneurial tradition conveyed in the photographs of physicians, dentists, barbers, and university presidents, and the images of community centers and self-help organizations all testify to the vibrancy of a community charting its own destiny.

The work also is a template for the key phases of American history. Here we see the struggle against slavery as reflected in various Underground Railroad sites. We witnessed Jim Crow segregation, northern style, in numerous renderings. We see a community mounting the challenge for civil rights, and responding to the call of black empowerment. We are provided with a visual sense of opportunities made possible by the legal transformations for which the community served as a catalyst.

We are indebted to our authors for a work that so richly conveys the story of a community asserting its presence and affirming its optimism.

Ronald C. Woods, J. D.
Professor, Eastern Michigan University
President, Board of Directors
African American Cultural and Historical Museum

INTRODUCTION

African Americans have only recently begun to exert control over black images. We have felt the impact of the use and misuse of our visual representations through the dissemination of hurtful stereotypes. In the past 20 years, books like *I Dream a World*, *The Face of Our Past*, and *Crowns* have framed and illustrated black achievement and culture. It is important now more than ever to develop understandings of our past and to remind ourselves of who we are, and what we want to become.

This book is our effort to make visible the invisible comings and goings of daily life that have usually gone unremarked. The result is a depiction of scenes from family, social, religious, and political life. In this book we pull back the curtain and let readers see a celebration of people who, through faith, will, and force of personality, turned this area into a thriving black community.

It is no coincidence that the Ann Arbor/Ypsilanti area should be populated with achievers. Historically the region was inhabited by risk-takers who felt the imperative to live free. They would not accept the constraints of slavery or a society closed to opportunity. Instead they chose to walk endlessly, north, south, and west, converging in Michigan, the center of the free Midwest.

We briefly visit historic locations on the Underground Railroad. Many African Americans came through Michigan via this system of safe houses for fugitive slaves. Some of our local heroes used the Underground Railroad to find freedom. We touch on this aspect of their lives.

The stories of African American pioneers are portrayed in this book. The founders of Ypsilanti and Ann Arbor met a small coterie of African Americans living in what is now Washtenaw County. From the early entrepreneurs and university students, to the athletes and civil rights protestors, a variety of accomplished as well as ordinary lives are shown in the book. The pictures cover a period from the 19th century to the beginning of the 21st. Many photographs are of average people in everyday life. Other pictures show the stories of community leaders, ministers, and others, grappling with the issues of their day.

The inexorable climb of African Americans up the economic ladder of this country is revealed in snapshots of black business people, politicians, educators, university officials, and others. We explore how the struggle for survival was honed into a force that created black churches, shopping districts, social clubs, sororities, fraternities, schools, and our neighborhoods. These black institutions were the strong and sturdy threads of our social fabric. These institutions were what we used to weave together a less visible but no less vibrant community.

Our hope is that *Another Ann Arbor* will illuminate the dignified lives of African Americans who have enriched our region.

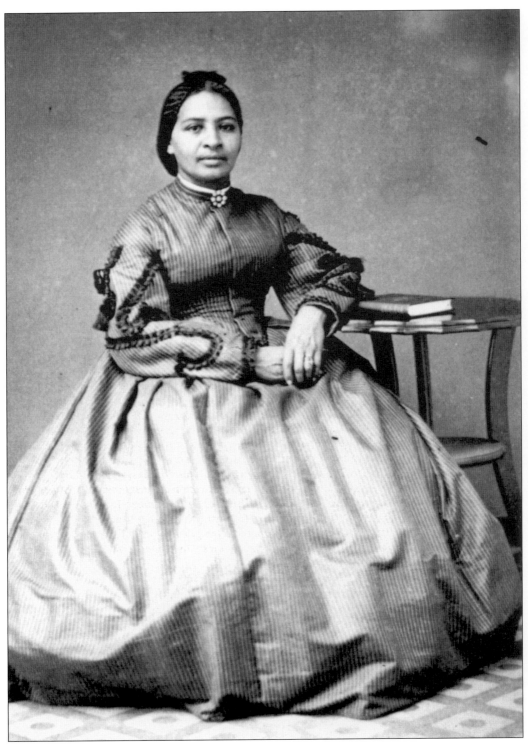

This unnamed upper-middle-class lady was a member of a family of successful African American farmers. Dressed in the finery of her day, she was able to sit for this photograph, a luxury that was out of reach for many Americans at this time.

One

THE EARLY YEARS

Through photographs and stories this book tells the history of black migration to the area, their settlement here, and how they fared. It covers the period from the 19th century to the 1930s. The census reports from that time indicate that 231 blacks were living in Washtenaw County as early as 1843. By 1850, two churches had been established here. The residents worked at various occupations. A drayman delivered luggage from the railroad station to residences. Barbers, a funeral parlor, and other small businesses flourished. Most were involved in service occupations. All blacks at this time were not poor, former slaves, or unskilled. Many of the African Americans migrating to Michigan brought skilled trades with them. Blacksmith, brick maker, carpenter, farmer, cooper, mason, teamster, are all trades that show up on the census of 1830 and 1860. After the Civil War, opportunities began opening up. In Michigan, black Civil War veterans became more vocal in speaking up for expanded freedoms. "Grant Clubs" sprang up to honor the Civil War general Ulysses S. Grant and to aid in black development. This emphasis on self-improvement allowed a few African Americans to strive and obtain an education against great odds. A few black firsts came to prominence: Elijah McCoy, the famous inventor and engineer; Ida Gray, D.D.S.; John Dickerson, M.D.; and George Jewett, University of Michigan athlete, coach, and dry cleaner, are a few who come to mind. Just 50 years after slavery, the *Michigan Manual of Freedmen's Progress* in 1915 documents how far the African American community in Washtenaw County had come.

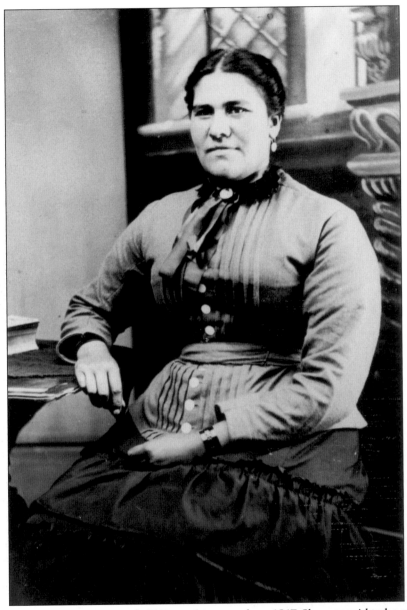

Mary Aray may have settled in Pittsfield Township as early as 1817. She was said to be part African American, Native American, and French Canadian. Her mother married an enslaved man in Pennsylvania. Aray came to the area with her husband, Jacob Aray, who also was from Pennsylvania. They owned a large farm in Pittsfield Township that they bought from a land speculator in 1827. The land opened up after Native Americans were forced to sign treaties transferring their land to the U.S. Government. The government gave or sold land to a favored few. These landowners generally resold the land, making a quick profit. The papers of Albert P. Marshall, Ypsilanti historian, identify Asher, James A., Harriet, Harvey, Jacob, and Martha as some of the Aray children. Asher Aray, their first born, was a noted mixed race, African American Underground Railroad conductor. History rarely records the deeds of blacks acting in this capacity. Asher operated out of his Pittsfield Township farm on what is now Michigan Avenue near Textile Road. The land remained in the Aray family for about 100 years. (Courtesy of Ypsilanti Historical Museum Archives.)

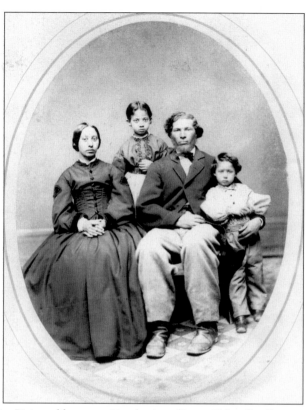

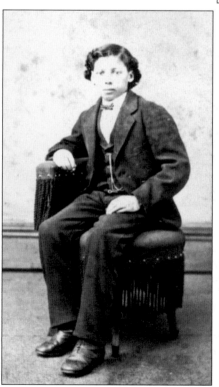

Pictured here are Martha Aray Day and her family. Martha is the daughter of Mary and Jacob Aray. She married into the prominent Day family, who were her neighbors. Martha's husband, seated to her right, was Benjamin Day. Their two children were Alice and Herbert T. Day, born in 1855 and 1860 respectively. Lillian Lucretia Bradley, the granddaughter of Martha Aray Day and great-granddaughter of Mary Aray, donated her families' historic photographs and papers to the Ypsilanti Historical Museum Archives. This donation leaves a significant legacy that documents the presence of free African Americans whose lives predate the Civil War. (Courtesy of Ypsilanti Historical Museum Archives.)

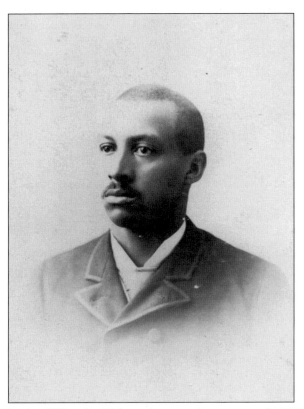

In the 1830s, the Midwest became the place of choice for African Americans seeking freedom. The South imposed harsher restrictions and penalties on free and enslaved blacks. The 1831 Nat Turner rebellion struck fear in white people, which triggered a backlash against free blacks. From 1830 to 1850, over 32,500 African Americans walked to the Midwest, fueling a Great Migration. One-eighth of all free blacks lived in Midwestern states by 1850. They traveled carrying documents to prove their status yet could be sold into slavery at any time. Midwestern states had Black Codes, which were laws meant to discourage free blacks from settling there. These codes often required expensive payments from African Americans. It was under these conditions that free blacks came to Washtenaw County and built their lives. (Courtesy of Ypsilanti Historical Museum Archives.)

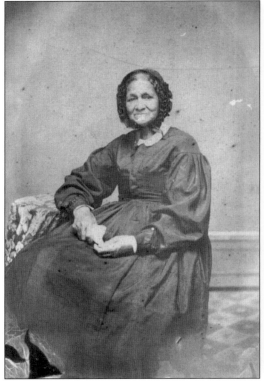

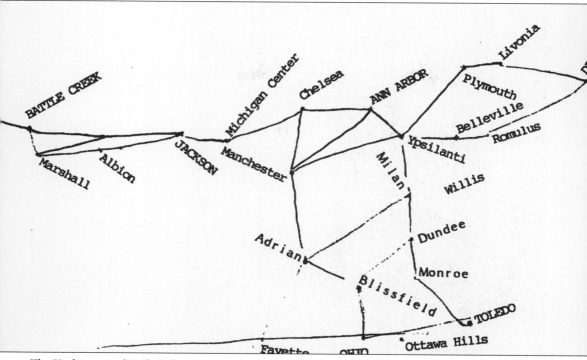

The Underground Railroad was an organized, covert system of transportation and safe houses for escaping slaves. Ypsilanti was the hub for most Michigan lines, ending at the Detroit River. Activity on the Underground Railroad picked up when abolitionists targeted the territory with the goal of getting it admitted into the Union as a free state. Loopholes existed that allowed slavery until Michigan gained statehood in 1837. (Courtesy of the A. P. Marshall Papers.)

The Huron Block was a building that stood on the east side of Broadway Street in Lower Town from 1830 to 1859. Recent research by the University of Michigan, Arts of Citizenship Program, reveals that this is where Guy Beckley published the famous antislavery newspaper *Signal of Liberty* from 1841 to 1848. (Courtesy of Bentley Historical Library.)

While living here on North River Street in Ypsilanti, the well-to-do Mark and Rocena Norris secretly supported the Underground Railroad. In 1861, Mark Norris built the Thompson block, a commercial and residential building in Depot Town. He used this and a former hotel built in 1838 as stations on the Underground Railroad. Only the house still stands. (Courtesy of Carol Mull.)

Pictured here is the Guy Beckley House at 1425 Pontiac Trail, which was an Underground Railroad station. Guy Beckley and his brother, Josiah, were neighbors in the Lower Town section. Guy was a Methodist minister, publisher, and coeditor of the *Signal of Liberty*, an antislavery newspaper. His coeditor Theodore Foster owned a store in Scio Township that doubled as a stop on the Underground Railroad. (Courtesy of African American Cultural and Historical Museum of Washtenaw County.)

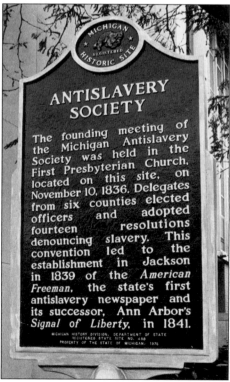

This antislavery plaque at the Ann Arbor News building on Huron Street marks the site where the founding meeting of the Michigan Antislavery Society took place. The meeting was held at the First Presbyterian Church on November 10, 1836. Delegates elected officers and adopted resolutions against slavery. The church held a strong antislavery position. This, in part, led to a split and the formation of today's First Congregational Church of Ann Arbor. (Courtesy of First Presbyterian Church of Ann Arbor.)

African American men came to the area to find work on the Michigan Central Railroad as laborers, firemen, and porters. Often they were transient workers building and repairing the rails after the Civil War. Ancillary jobs were created, helping make Ann Arbor a friendly town for African American women too. (Courtesy of Ann Arbor Community Center.)

African Americans also benefited from the University of Michigan's building boom. The campus expanded rapidly under Pres. James B. Angell. This created an opportunity for black masons, carpenters, and other skilled laborers to find work. They constructed many of the university buildings and gracious homes of this area. Ann Arbor's African American population soared by nearly 50 percent between 1900 and 1910. (Courtesy of Ypsilanti Historical Museum and Archives.)

Elijah McCoy was born in Ontario, Canada, on May 2, 1844. His parents escaped slavery in Kentucky. After the war, the family moved to a farm in Ypsilanti. Elijah's father, George, was a cigar maker. As he delivered cigars to Detroit, he hid escaping slaves in the false bottom of his wagon. As his business expanded, so did his covert operation. This historic marker, located at 229 West Michigan Avenue in Ypsilanti, commemorates the life of Elijah McCoy. McCoy apprenticed with a mechanical engineer in Scotland. When he returned, he worked for the Michigan Central Railroad. He invented a device to lubricate train wheels. McCoy patented over 50 inventions. He often sold his patents in order to operate his business. On October 10, 1929, he died in the Eloise Public Hospital in Detroit. (Above, courtesy of Ypsilanti Historical Museum Archives; below, courtesy of Another Ann Arbor, Inc.)

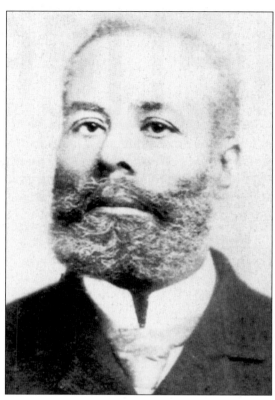

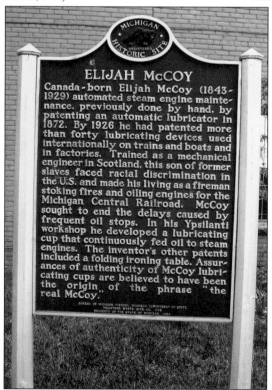

ELIJAH McCOY

Canada-born Elijah McCoy (1843-1929) automated steam engine maintenance, previously done by hand, by patenting an automatic lubricator in 1872. By 1926 he had patented more than forty lubricating devices used internationally on trains and boats and in factories. Trained as a mechanical engineer in Scotland, this son of former slaves faced racial discrimination in the U.S. and made his living as a fireman stoking fires and oiling engines for the Michigan Central Railroad. McCoy sought to end the delays caused by frequent oil stops. In his Ypsilanti workshop he developed a lubricating cup that continuously fed oil to steam engines. The inventor's other patents included a folding ironing table. Assurances of authenticity of McCoy lubricating cups are believed to have been the origin of the phrase "the real McCoy."

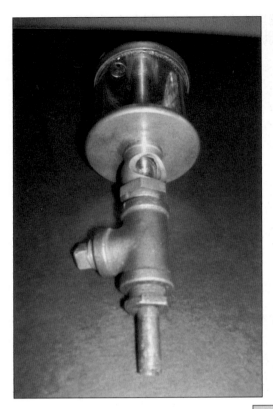

Pictured here is the actual automatic oiler cup that Elijah McCoy invented in 1872. It is located in the Ypsilanti Historical Museum. The device revolutionized train transportation because engineers did not have to stop the train continuously to oil the moving parts. Imitators tried to compete, but none were as good as "the real McCoy." (Courtesy of Another Ann Arbor, Inc.)

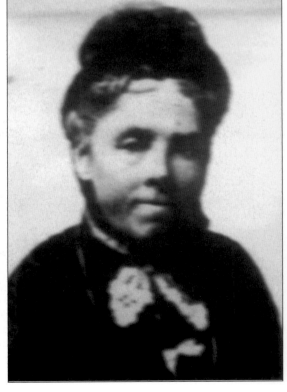

Dr. Helen McAndrew and her husband, William, came to Ypsilanti from Scotland in 1849. He was a businessman, and she was the first female doctor in the area. They were both abolitionists. She taught many black children to read and write and treated them with respect. She continued to teach long after slavery was abolished. She is said to have paid for Elijah McCoy's education in Scotland. (Courtesy of Ypsilanti Historical Museum Archives.)

Fredrick B. Pelham was one of the first African American graduates in civil engineering at the University of Michigan. He graduated in 1887. He built many bridges for the Michigan Central Railroad. He is known for his unique split-beam construction design. His Dexter-Pinckney Road Bridge, built in 1890, is still in use today. (Courtesy of Bev Willis.)

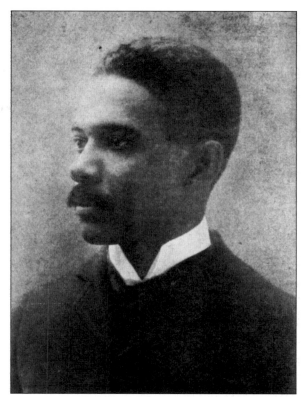

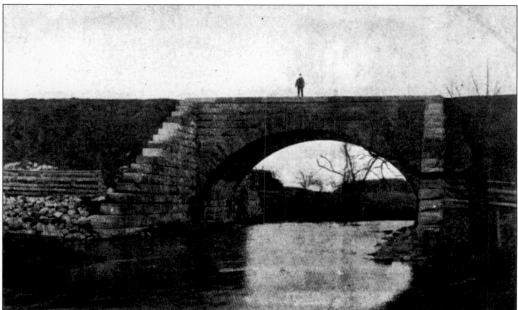

Fredrick B. Pelham designed over 18 of these bridges for the Michigan Central Railroad line between Detroit and Chicago. Coincidentally, Pelham's niece rode the railroad on the way from her native Missouri to attend school in Detroit. Whenever the train approached a Pelham bridge, she always exclaimed, "My uncle built that bridge!" Three bridges exist in Dexter currently. Amtrak riders speed over two of them daily. (Courtesy of Bev Willis.)

George Henry Jewett Jr. was born in 1870 into the family of a wealthy blacksmith. Jewett could speak German, Italian, and French fluently. He was captain of the debate, football, and baseball teams, and he was named the fastest sprinter in the Midwest. Jewett graduated as class valedictorian from Ann Arbor High School. In 1890, he entered the University of Michigan to study medicine. Jewett was the University of Michigan's first black varsity football player. He was voted cocaptain of that team and captain of the track team. In 1893, he transferred to Northwestern University where he could continue his medical studies and play football. He then practiced in medicine in Chicago. Later he opened The Valet, a successful dry-cleaning business on North State Street, near William Street, next to what is now First Congregational Church of Ann Arbor. Jewett died of a heart attack at work in 1908. (Courtesy of Bentley Historical Library.)

Historic Forest Hill Cemetery was established in 1857. This is the city's oldest cemetery. Several African Americans are laid to rest here. Most are buried in section B on the eastern edge next to the arboretum. Rev. Charles Carpenter, pastor of the Second Baptist Church of Ann Arbor; Mrs. Carpenter; Lillian Zebbs-Jewett; George Jewett Jr.; his parents and family; his first cousin Letty Whitcliffe; and Eva Jesse, a nationally known opera singer, rest here as well. (Courtesy of Another Ann Arbor, Inc.)

This Greek Revival-style building was the first black church in Ann Arbor. The Union Church was located at 504 High Street. It appears on the 1853 map of Ann Arbor. In 1871, a split in the congregation occurred. Out of that split, Bethel African Methodist Episcopal Church (Bethel AME Church) and Second Baptist Church of Ann Arbor evolved. The Union church building stands today. It has been converted into an apartment house. (Courtesy of African American Cultural and Historical Museum of Washtenaw County.)

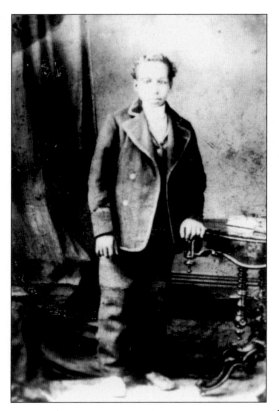

George Kersey and his brothers were born on a Canadian reservation near Buxton, Ontario, to an Apache mother and an African American father. They came to Ypsilanti in the 1880s to find work. George, the oldest, went into farming. His brothers, James and Herman, were skilled carpenters. They all settled near each other between First and Second Streets near Michigan Avenue in Ypsilanti. (Courtesy of Ypsilanti Historical Museum and Archives.)

George Kersey, along with his brothers, James and Herman, helped build Brown Chapel, a historic, Gothic-style church on Buffalo Street in Ypsilanti. It is Ypsilanti's oldest African American church. The Kerseys also helped many families build their homes. Their descendants have continued to be active Ypsilanti residents, organizing a community chorus, teaching at Adams (now Perry) School, and leading an Eastern Michigan University union. (Courtesy of Ypsilanti Historical Museum and Archives.)

Ida Gray, a graduate of the University of Michigan, was the nation's first black female dentist. Born in 1867, she grew up in Cincinnati. Gray received her dental degree in 1890. After graduation, she returned to Cincinnati where she established a very successful practice. In 1895, Gray married and moved to Chicago. She remarried in 1929, after being widowed. The well-respected Gray was heralded as an example of what black women could achieve. (Courtesy of Bentley Historical Library.)

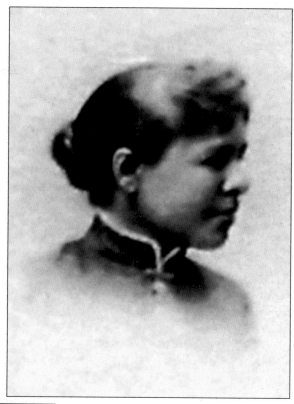

Dr. Katherine Louise Crawford was born in Ann Arbor in 1870. Her family lived at 910 Greene Street. She was admitted to the University of Michigan Medical School, graduated as a physician in 1894, and set up a practice in Ann Arbor at 1116 Fuller Street. She died at age 84. (Courtesy of Bentley Historical Library.)

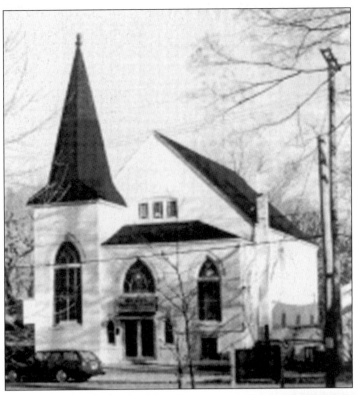

In 1891, under the leadership of
the Reverend Howard Cottman,
construction of Bethel AME Church
began at 632 North Fourth Avenue.
The completed building was dedicated
in 1896. An outstanding feature was
its distinctive steeple. A group of
young adults known as the Furnishing
Club raised funds to provide pews,
chandeliers, and other necessities for
the church. During the next few years,
Bethel struggled financially and the
building was put up for auction. In a
tense moment just before the gavel
fell, trustee Stephen Adams came
forward and pledged his home to save
the church. As the congregation grew
and prospered, the church built a new
edifice at 900 Plum Street, now John A.
Woods Drive. The "Old Bethel" church
was sold to Grace Apostolic Church in
1971. Today the building is a modern
condominium. (Courtesy of Another
Ann Arbor, Inc.)

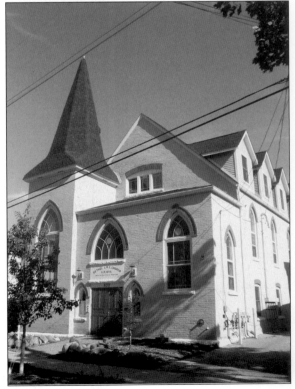

Charles Henry Shoeman was a popular Ann Arbor poet who gave numerous readings of his work around Michigan. Bookstore owner George Wahr published Shoeman's book of verse in *A Dream and Other Poems*, in 1899. His work was well received and commended. He disappeared sometime after the book was published. No information is available about his later life. (Courtesy of Ann Arbor Argus.)

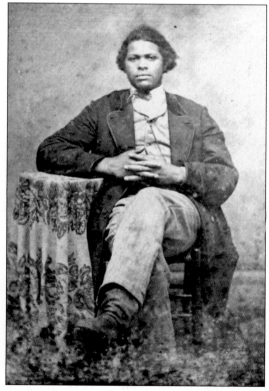

Here is a well-dressed man of his day in a cuffed frock coat with wide lapels, short tie, stand-up shirt collar, rolled-collar waistcoat, and plain leather boots. His is a typical man's suit from the 1870s that was fashionable and well worn. The gentleman is a descendant of Mary Aray. (Courtesy of Ypsilanti Historical Museum.)

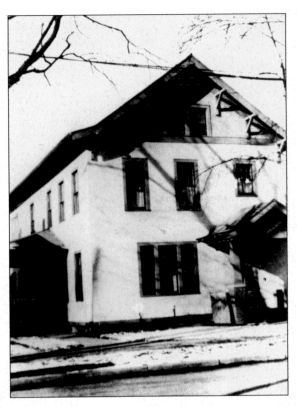

This was the home and office of Dr. John H. Dickerson at 309 North Washington Street in Ypsilanti. He also operated a small hospital on site because most hospitals were segregated. Dickerson was born in Baltimore, Maryland, and graduated from Howard Medical Department in Washington, D.C., in 1895. He was a surgeon in the Spanish American War, holding the rank of captain. After mustering out, he settled in Ypsilanti. (Courtesy of Ypsilanti Historical Museum and Archives.)

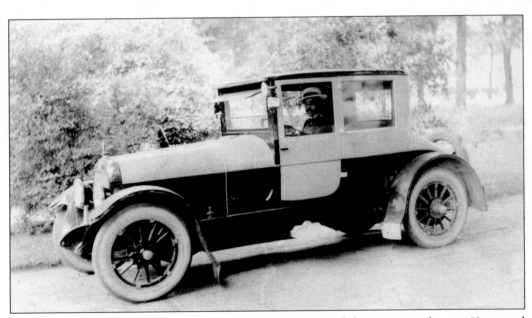

Here is Dickerson in his beloved "fine car," which he enjoyed driving around town. He served both Ann Arbor and Ypsilanti communities as a doctor for 25 years. He suffered from asthma and at age of 56, died in an ambulance on his way to St. Joseph's Mercy Hospital. (Courtesy of Ypsilanti Historical Museum and Archives.)

The family home that James Kersey built still stands on First Avenue. He, along with his brother Herman, was a skilled carpenter who built many houses in the surrounding community. James helped build Pease Auditorium at Eastern Michigan University. The Kersey neighborhood was sometimes referred to as Kerseyville. When one of James's children married, he gave them a piece of land on which to build their house. He owned a large tract of land, originally a peach orchard, on First Avenue near Michigan Avenue. He drafted the blueprints for Brown Chapel, Ypsilanti's oldest church. The pastor and trustees met at his home on weekends to study the plans. Church services were even held in his basement while the church was under construction. James dedicated a window to his son Ernest; it can be seen in the church today. The family home, which he built, still stands. James's granddaughter, Rolanda Hudson, still lives there today with her brother, Don Kersey. (Courtesy of Another Ann Arbor, Inc.)

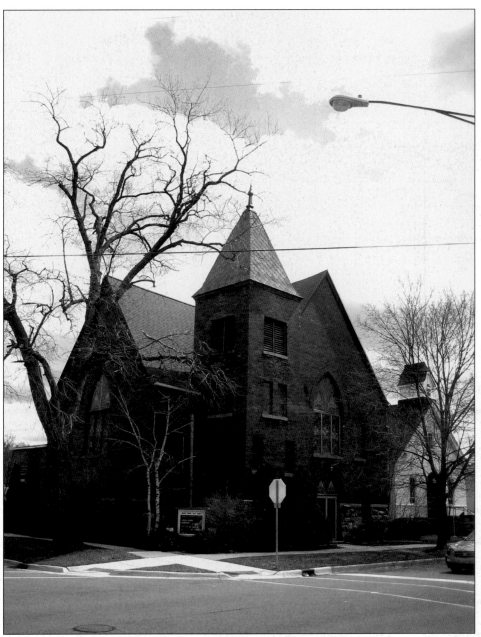

Known today as the Old Brown Chapel, this stately neo-Gothic structure stands at the corner of Buffalo and Adams Streets in Ypsilanti. Sylus Jones and Flora Thomas began holding religious services in their homes in 1843. The small congregation bought a plot of land at Adams and Buffalo Streets and held services in a frame building on the lot. In 1901, Rev. Lewis Pettiford made the decision to construct a new building. James Kearsey drew up the blueprints and supervised the construction, along with his brother, George. Weltha Sherman went all over town gathering needed bricks and other materials and brought them to the building site in her wheelbarrow. The building was completed in 1904. Auxiliaries of the church raised funds to provide pews, chandeliers, and other furnishings. The building was completed in 1904. (Courtesy of Another Ann Arbor, Inc.)

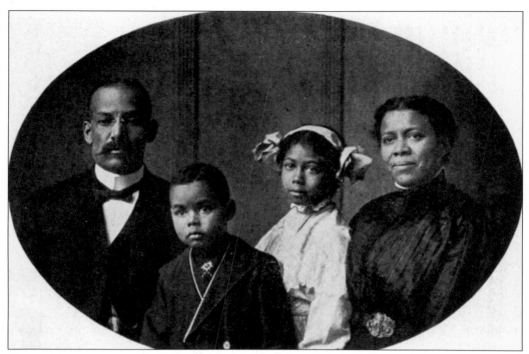

Pictured here is Henry Wade Robbins with his wife and two children. They are listed in the *Michigan Manual of Freedmen's Progress* of 1915. A native of Canada, Robbins came to Michigan in 1884. He owned a comfortable home in Ann Arbor. (Courtesy of Bev Willis.)

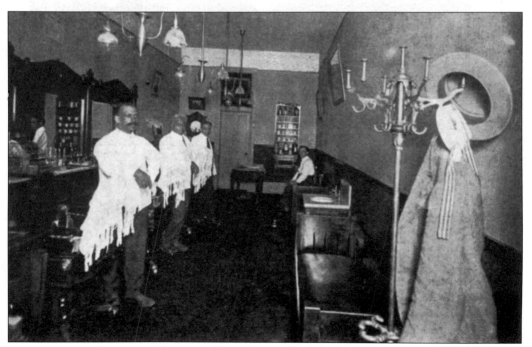

Here is a view of Henry Robbins's exclusive barbershop in Ann Arbor. He had patrons of both races, including state officials and churchmen. He is said to have been an astute businessman who owned some of the best business property in the city. (Courtesy of Bev Willis.)

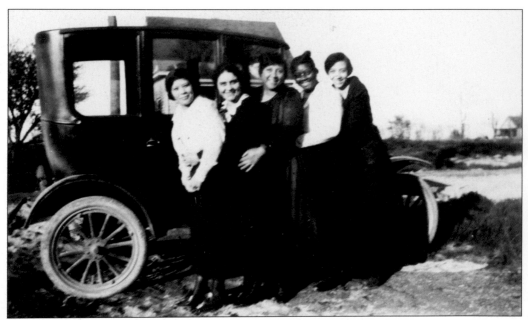

Lena Wayner (left) and girlfriends pose in front of a car on Greene Street in 1915. Automobiles were becoming common in Ann Arbor at this time. In fact, the Huron River Manufacturing Company built a handful of cars here before World War I. An early pamphlet promoted Ann Arbor as "the automobile centre of the world" in a wild hope to attract automobile manufacturing to the area. (Courtesy of Bev Willis.)

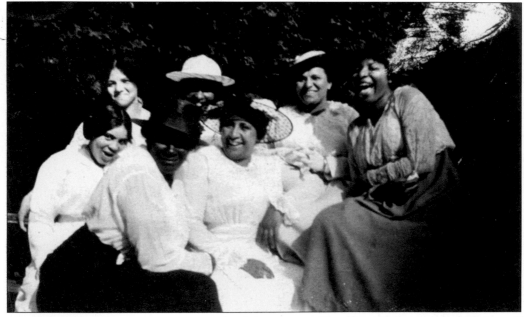

A smiling group of Ladies are enjoying a birthday party on Woodlawn Street, about 1915. Just off Packard Street, Woodlawn Street represents another area where blacks were able to establish a neighborhood for themselves. Black neighborhoods were growing as the African American population in Ann Arbor nearly doubled between 1900 and 1910. The well-dressed ladies with their beautiful hats paint a picture of the times. (Courtesy of Bev Willis.)

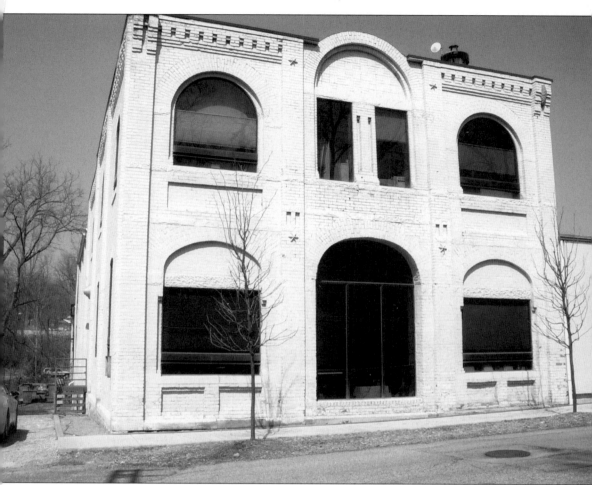

The Ann Arbor Foundry opened in 1920 when a group of foundry workers who were laid off from the Production Foundry on North Main Street in Ann Arbor decided to form a company. They set up shop in an old brewery at 1327 Jones Drive. Charles Baker, an African American, partnered with Tom Cook, a Russian Jew, in a unique arrangement where employees shared profits at year's end. The work was hot and difficult, but they were committed and made money. They all worked together as a family. At lunch they could look down and see cows grazing on an unpaved Plymouth Road. The friendship between the two men was real and enduring. They continued the partnership from 1920 to 1972, when new governmental regulations forced them to close. The building has since been renovated and has new life as a law office. (Courtesy of Another Ann Arbor Inc.)

The James L Crawford Elks Lodge, No. 322, formerly the Elks' Pratt Lodge, was chartered in 1922. It is the oldest chartered lodge in the state. Following tradition, the new lodge was named after Pratt, the first of its founding members to die. In 1944, as membership swelled, the Pratt Lodge purchased its current home at 220 Sunset Road. In December 1961, brother James L. Crawford was elected exalted ruler of the lodge. He won reelection 36 times. In 1977, Gov. William Millikin congratulated the lodge on its "dedication and contributions to the society in which they worked and lived." In 2003, James L. Crawford passed away, and in 2004, the lodge name was officially changed to the James L. Crawford Elks Lodge, No. 322. Jerome Hall became the lodge's new leader. The lodge continues to be involved in worthwhile endeavors, both nationally and locally. (Courtesy of Another Ann Arbor, Inc.)

Members of the David Thomas family were early residents of Ann Arbor. David was a business owner. His son Mallory was the first black player on Ann Arbor High School's 1937–1938 varsity basketball team. Mallory dropped out of Michigan Normal College (now Eastern Michigan University) and made a career in the armed forces. More than 50 years later he returned to college and graduated from Eastern Michigan University with his grandson. (Courtesy of Mallory Thomas.)

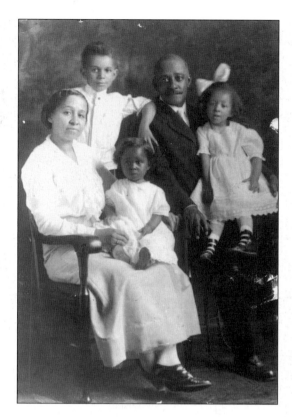

David Thomas poses in front of his barbershop on Main and Washington Streets in Ann Arbor, about 1925. It was unusual for African Americans to own a business, especially one on Main Street, but Mallory Thomas says his father did not have a problem and he had customers of all races. (Courtesy of Mallory Thomas.)

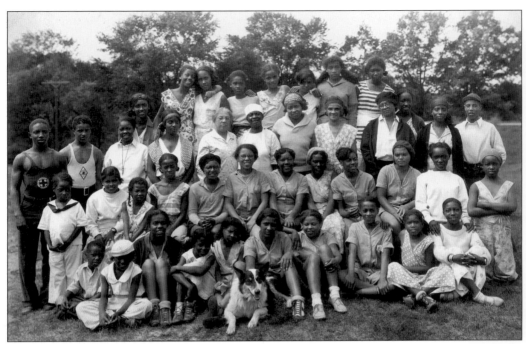

Children gather for a moment to take a picture with their camp counselors and lifeguards on this bright summer day. Even a family dog took part in the fun. Much like today, this 1926 summer camp provided supervision along with opportunities for swimming, picnicking, and other games and recreation. (Courtesy of Bev Willis.)

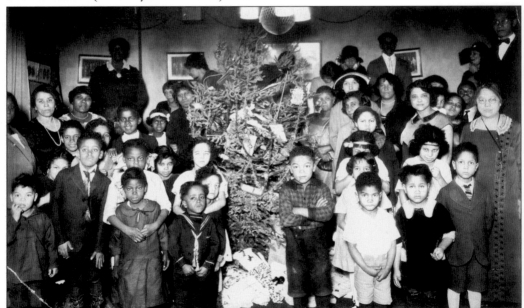

Children look forward to the annual Golden Rule Christmas Party, about 1926. This annual celebration was sponsored by one of the black community's oldest women's clubs in town. Historically, black women's clubs did charity work to improve the lives of children. The Palm Leaf Club, Elks Auxiliary, and L'Esprit are some of the clubs active at this time. (Courtesy of Ann Arbor Community Center.)

Two

CREATING A COMMUNITY

Along with the growing population, and more earning power, came the need to build a community. African American churches and social clubs were founded due to segregation and the continuous drive to develop a culture that reflected their shared history. African American congregations split from their white counterparts when being segregated in balconies became unacceptable. Schools sprung us to educate the first generations living in freedom. With increasing earning power and leisure time, clubs provided places to socialize and fund-raise as well.

The church has been central to black community life. Many women made their chief contributions to the community through service to the church. The major churches in Washtenaw County during the 1940s were Second Baptist Church and Bethel AME in Ann Arbor, and Brown Chapel in Ypsilanti.

After World War I, black soldiers returned home and fought for the rights of African Americans. The Detroit automobile plants began to gear up, and the Great Migration, the largest relocation of blacks from the South to the North, was underway. Between the relatively high wages of the automotive industry, the railroad, and the universities, some African Americans were doing well and looking for ways to help their community.

Many of the photographs portray ordinary people in everyday life, enjoying picnics, school activities, teas, and debutante balls of the 1930s, 1940s, and 1950s. Other photographs tell stories of community leaders, ministers, and educators.

This chapter gives special attention to the Dunbar Community Center because it typifies black life in the county at that time. Churches, clubs, and fraternal organizations played a similar role. This chapter shows how African Americans carried out their lives and made a place for themselves in this area.

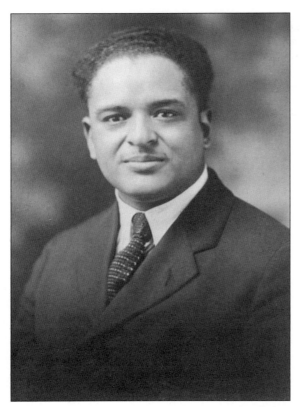

Rev. R. M. Gilbert, pastor of the Second Baptist Church of Ann Arbor, established the Dunbar Community Center in 1923. He received financial assistance from the community fund to repair a building at 209–211 North Fourth Avenue. His purpose was to create a rooming house for workmen who came to Ann Arbor for temporary employment. The building was also used for social events. Expenses were paid from rents and membership certificates. (Courtesy of the Ann Arbor Community Center.)

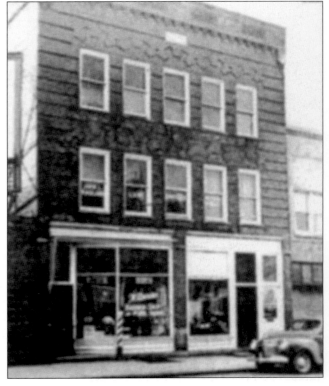

This structure was sometimes called the Kayser Block Colored Welfare Building. Savonia L. Carson was appointed executive secretary in 1926. Later the center was moved to 1136 Catherine Street. The building was sold to J. D. Hall, who turned it into a barbershop and rooming house. (Courtesy of the Ann Arbor Community Center.)

Booker Brooks was the first black letterman in track at the University of Michigan. He won letters in 1929, 1930, and 1932. He was the 1930 Big Ten discus champion and placed second in the NCAA shot put. He also competed in the 1932 Olympic trials. Later he earned a master's degree in social work and became the first black supervisor with the Michigan Department of Social Services. He died in 1968. (Courtesy of University of Michigan Athletic Department.)

These two young men are going out in all their finery. Their suits are from about the 1920s. At that time, car coats and newsboy caps were still popular from the beginning of the century. To the right, the Barrymore shirt collar worn with a vest and floppier pants are the height of fashion. (Courtesy of Robert Hunter.)

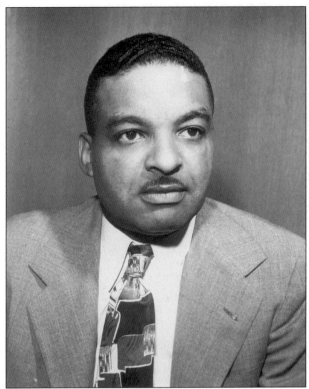

Douglas Williams was hired by Rev. R. M. Gilbert to manage the Dunbar Community Center in 1936. Williams was a pharmacist and also held a certificate from the Atlanta School of Social Work. He arranged the purchase of the red brick building at 420 North Fourth Avenue, in the heart of the black community. He revitalized the center's programming and increased membership from 57 to 371. (Courtesy of Ann Arbor Community Center.)

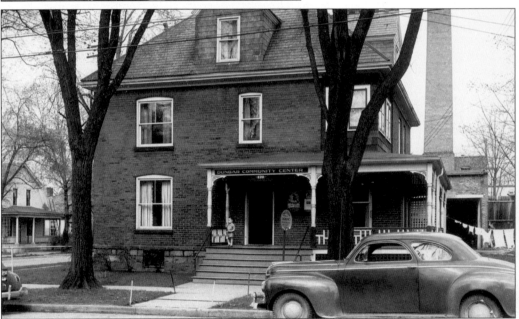

The Dunbar Community Center was named for the famous 19th-century poet Paul Lawrence Dunbar. It became a focal point of African American life, providing recreational activities, information, and referrals for blacks in the area. It was the forerunner of the Ann Arbor Community Center. Douglas Williams became the longtime director and a pivotal community leader. (Courtesy of Ann Arbor Community Center.)

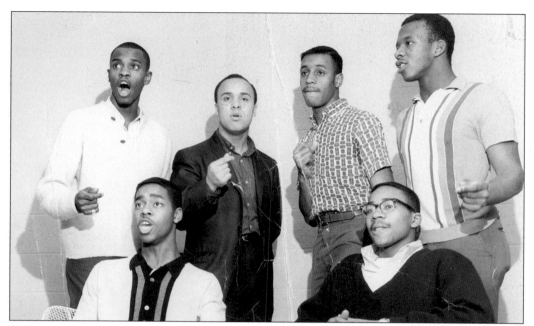

The male chorus created at the Dunbar Community Center attracted an enthusiastic and growing response. This grew into one of the main attractions of the center. The chorus often performed on social occasions. Willis Patterson, professor emeritus of music and assistant dean at the University of Michigan School of Music, received some of his first performance experience at the center. (Courtesy of Ann Arbor Community Center.)

A Boy Scout affiliated with the Dunbar Community Center carries a banner in a local parade in 1945. The troop's longtime leader was Vernon "Archie" Adams. He instilled the values of integrity and self-sufficiency, and the importance of respecting and helping their elders. The center used Community Chest funds to help support its operation. (Courtesy of Ann Arbor Community Center.)

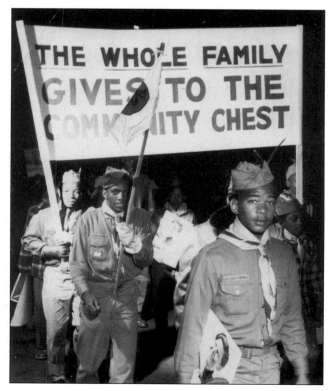

Children skip down the steps of the Dunbar Community Center with assistant director Virginia Ellis, about 1940. Dancing, crafts, and home economics were just some of the classes and activities held at the Dunbar. The programming philosophy at this time was to offer social and recreational opportunities for the African American community. The center was an especially important and lively outlet during segregation. (Courtesy of Ann Arbor Community Center.)

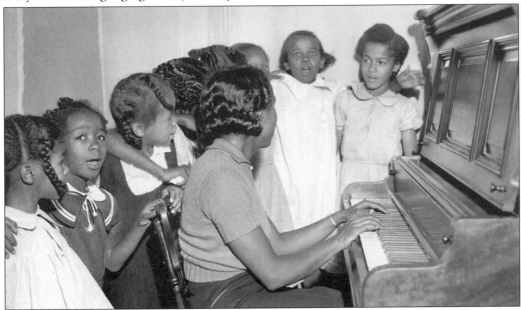

In this photograph, young girls are enjoying a singing lesson with Virginia Ellis at the Dunbar Community Center, around 1940. The expanded programming instituted by Doug Williams, the center's director, was widely popular. Music and arts programming were a part of the new emphasis on the cultural and recreational activities that helped membership soar. (Courtesy of Ann Arbor Community Center.)

Ann Arbor's Kayser Block building is where John L Ragland began practicing law in 1941. He was the city's first black attorney. He helped organize the Civic Forum, which was a precursor of the NAACP. In 1916, Ragland's family moved to Ann Arbor. He attended Ann Arbor Public Schools and the University of Michigan Law School. Ragland was a founding member of the Alpha Phi Alpha fraternity there. (Courtesy of Ann Arbor Community Center.)

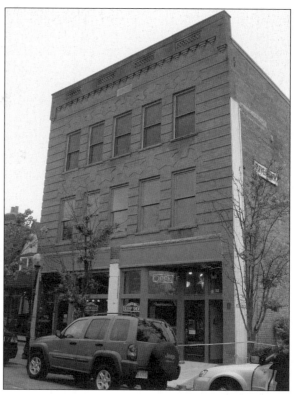

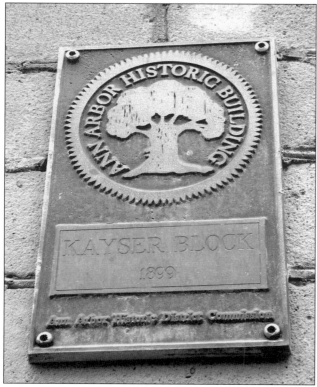

This historic building marker was placed on the Kayser Block, located at 209–211 North Fourth Avenue, by the city of Ann Arbor on recommendation of the city council. It reads simply "Ann Arbor Historic Building." The building was owned by the Colored Welfare League in 1923 when it was purchased by J. D. Hall. (Courtesy of Another Ann Arbor, Inc.)

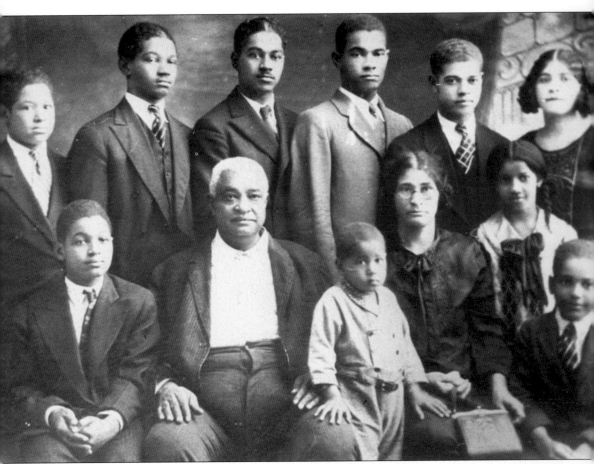

The Ellis family arrived in Ann Arbor from Chandler, Oklahoma, in the early 1940s. Six family members moved to Ann Arbor to attend the University of Michigan. All made contributions to Ann Arbor in areas of education and community life. Wade Ellis came to the university to earn his doctorate in mathematics. He had a highly successful academic career, including the position of associate dean of the Rackham Graduate School. Herb Ellis received his master's degree in education and was one of the earliest African American public school teachers in Ann Arbor. Roberta Ellis Britt operated a residence hall for black women students, a necessity of the times. Frank Ellis was a district court magistrate, a veteran's counselor, and a businessman. Pictured from left to right are (first row) Ora H. Ellis, Whit Ellis Sr., George S. Ellis, Maggie Ellis, Margaret Ann Ellis, and Francis E. Ellis; (second row) Hasko V. Ellis, James R. Ellis, Wade Ellis, Cliff Ellis, Whit Ellis Jr., and Roberta Ellis. (Courtesy of www.ellisfamilystory.com.)

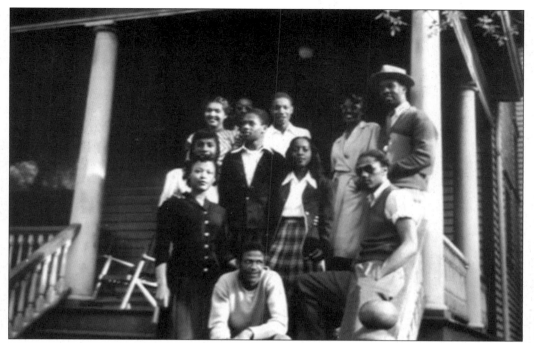

A favorite place for university students to come calling was the "B" House at 1136 Catherine Street. Roberta Britt was like a mother to the girls in her charge. Another social attraction for black students was the Dunbar Community Center with its many activities and events. It was here that Herb and Virginia Ellis met and married a year later. (Courtesy of Herbert Ellis.)

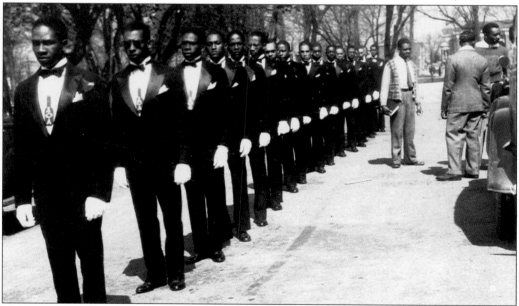

These young men represent the Alpha Phi Alpha fraternity, Inc.-Epsilon Chapter, at the University of Michigan around 1940. They are preparing for a step show. A step show was a traditional competition between various black Greek organizations. Their chapter was founded on April 10, 1909. More recently, they have sponsored many programs, including a scholarship pageant, voter registration drives, and tutoring. (Courtesy of the Ellis family.)

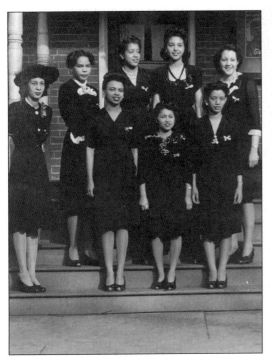

Here are eight undergraduate students at the University of Michigan in 1945 that have been pledged to the Alpha Kappa Alpha sorority. The sorority affiliation gave them a sense of belonging and support on the large university campus. Many of the pledges were housed at the Britt House on Catherine Street. (Courtesy of Ann Arbor Community Center.)

A birthday party is always a special occasion. These four-year-olds take a moment from play to have their picture taken in their party clothes. The birthday cake is front and center. Regardless of circumstances, families usually found a way to observe birthdays and enhance their children's self-esteem. (Courtesy of Robert Hunter.)

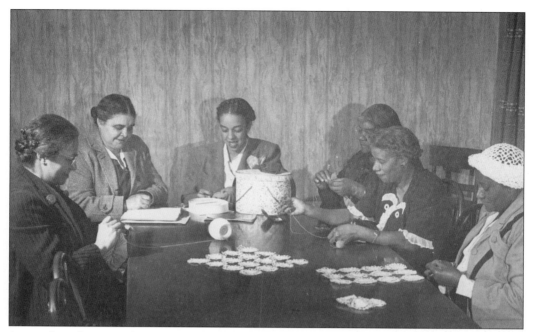

Arts and Crafts were a big draw for women's groups at the Dunbar Community Center. Knitting and other needlework regained popularity during and after the war. Pictured here are, from left to right, an unidentified woman with Lena Wayner; Catherine Williams, the wife of Douglas Williams; an unidentified woman; and Mrs. Cooper and Lillian Brown helping to assemble an afghan. (Courtesy of Ann Arbor Community Center.)

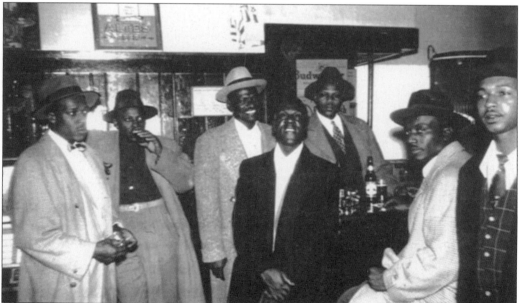

The universities, the railroad, and the Willow Run Bomber Plant all contributed in making Ann Arbor a good working town for blacks. After a hard week's work, the thriving, black-owned entertainment and business district on Ann Street was a friendly place to relax with friends. Whitman's Pool Room, the Midway Luncheon Restaurant, Easley's Barbershop, and Julie's Tea Room were a few popular establishments. (Courtesy of Robert Hunter.)

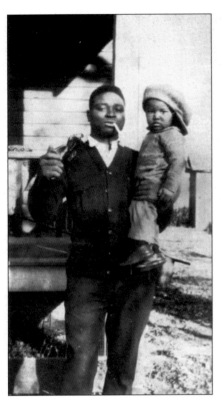

A proud Ypsilanti father holds his son. The area afforded different opportunities from the South. Children were able to stay in school longer, attending at least through junior high. They were not forced to do agricultural work to help supplement the family's income. Children could attend church camp, the Dunbar or Parkridge Community Centers, or perhaps follow sports with dad. (Courtesy of Robert Hunter.)

Joe Louis, heavyweight boxing champion of the world from 1937 to 1948, grew up in Detroit. Although he moved away from his hometown, he never forgot his roots or lost his common touch. Here he is seen visiting with young friends and fans in Ypsilanti.

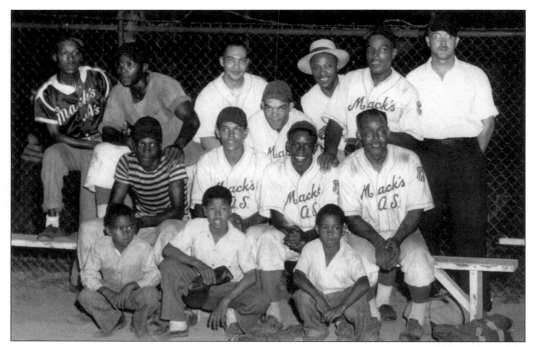

A young Al Wheeler played on the local Mack baseball team that won a regional championship. Wheeler is pictured in the back row, center. He enthusiastically participated in all sports in high school and was a student council member. He finished high school at age 16 at the head of his class while engaging in extracurricular activities and working part-time. (Courtesy of Coleman Jewett.)

Chesley "Chester" Gray was a catcher in the Negro Baseball League from 1940 to 1945. He played for the St. Louis Stars, the New York Black Yankees, and the Kansas City Monarchs. Gray was an active member of Bethel AME Church, singing in the men's chorus and participating in annual Men's Day programs. He and Mel Duncan, a pitcher with the Kansas City All Stars from 1949 to 1955, were hometown heroes. (Courtesy of Another Ann Arbor, Inc.)

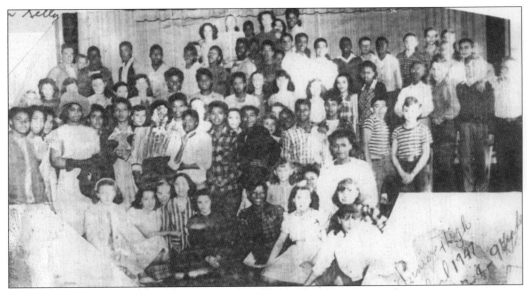

Junior high students in Ann Arbor come together for a group photograph in 1947. Most students are from the north-central neighborhood and have attended Jones School together since kindergarten. Everyone, including the teacher (second row, left), is dressed up for picture day. (Courtesy of Ann Arbor Community Center.)

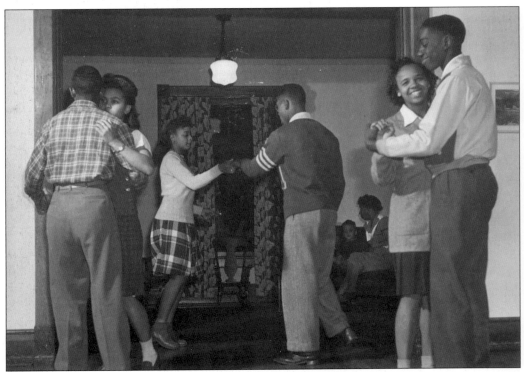

The Dunbar Community Center provided a space for teenagers to dance. Favorite dance steps included swing, the Lindy Hop, and the jitterbug. Big band music was popular, with Count Basie, Benny Goodman, and Cab Calloway topping the charts. Teenagers and adults danced to the same music. (Courtesy of Ann Arbor Community Center.)

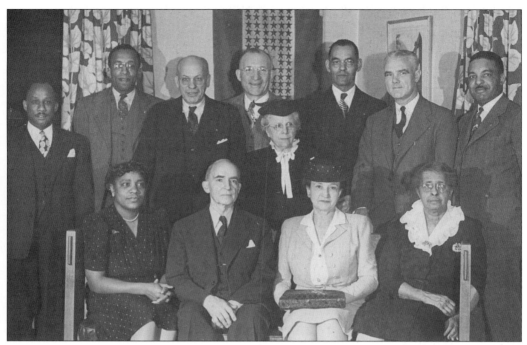

Executive director Douglas Williams and assistant director Virginia Ellis meet with one of the many corporate boards that helped to determine policy for the Dunbar Community Center. The United Way executive board was one organization that contributed to their support. Williams was skillful in negotiating on behalf of the center. (Courtesy of Ann Arbor Community Center.)

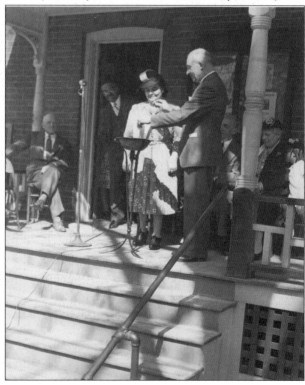

On May 14, 1944, the Dunbar Community Center retired its mortgage on the building. It was a celebrated event held on the porch of the center before a large group of guests and community leaders. The mortgage was symbolically burned in a metal urn to the applause of all. (Courtesy of Ann Arbor Community Center.)

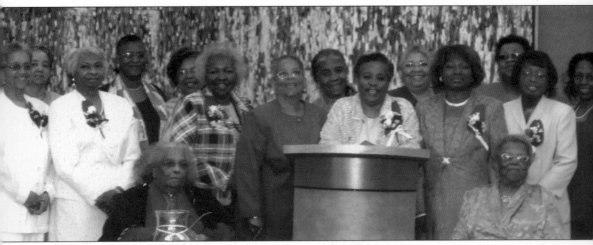

The Palm Leaf Club, originally called the Trustee Helpers of Brown Chapel AME Church, organized on October 30, 1904, in Ypsilanti. The founding members were president Emma Anderson, Nellie Green, Mary Jones, Margaret McCoy (wife of Elijah McCoy), Amanda Moore, Temperence Woods, Mary Ann Kersey, Rebecca Ward, and Elizabeth Martin. Honorary members of the club are Doris Clay, Rolanda Hudson, Jean Palmer, and Betty Stevens. The first project was to purchase chandeliers for the just-completed church building. In the 1930s, the group took the name Palm Leaf Club while abandoning the name Trustee Helpers, they participated in the establishment of Parkridge Community Center and the Women's Clubhouse on Washington Street. Pictured here are recent members who continue to provide funds for scholarships and support Meals on Wheels, Stand for Children, and numerous other community endeavors. Current members are, from left to right, (first row, seated) Doris Clay and Rolanda Hudson; (first row, standing) Lois Richardson, Mary Louise Foley, Eva Warren, Sandra Kamuyu, Peggy Taylor Harrison, Myra Ervin, and Mary Hatter; (second row, standing) Linda Francois, Paulette Dosier, Barbara Davis, Verda Clark, Constance Taylor, Wilma Ratcliffe, and Valery Eaglin. (Courtesy of Palm Leaf Club.)

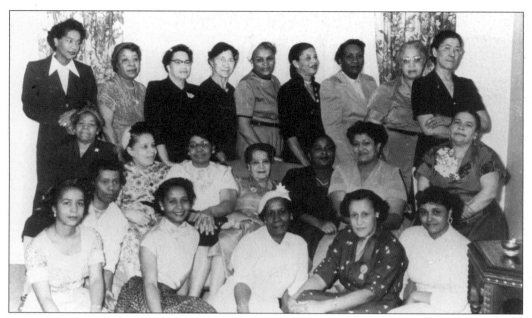

Pictured here is a Palm Leaf Club meeting around 1956. In attendance are, from left to right, (first row) Jean Palmer, Evelyn Beatty, Betty Adkins, Edna Kersey, Vida Vest, and Geraldine Kersey; (second row) Margaret Russell, Ethel King Neely, Florence Harris, Bessie Starks, Bessie Newton, Yvonne Williams, and Glenna Starks; (third row) Gertrude Francois, Doris Smith, Hazel Reed, Grace Aray, Anna Van Slyke, Estelle Lowe, Mazerline Moore, Gladys Benon, and Martha Jackson. (Courtesy of Ypsilanti Historical Museum and Archives.)

The Ypsilanti Association of Black Women's Clubs was initially located on First Avenue. Later the association purchased this beautiful Colonial house at 319 South Washington Street, so that African American women's organizations would have an appropriate place to meet. The clubhouse became the home of numerous gatherings. The Palm Leaf Club was a leading force in establishing this building. Women's groups continue to meet here today. (Courtesy of Another Ann Arbor, Inc.)

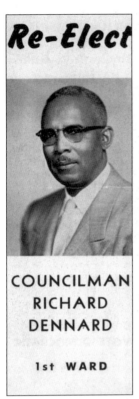

Richard Dennard was first elected to the Ann Arbor City Council from the first ward in 1957, and reelected in 1958. Some of the projects he initiated or supported include the urban renewal program, the Plymouth Road overpass for schoolchildren, and the Summit Street and Northside Park improvements. He was also a member of the Human Relations Commission. (Courtesy of Mrs. Pauline Dennard.)

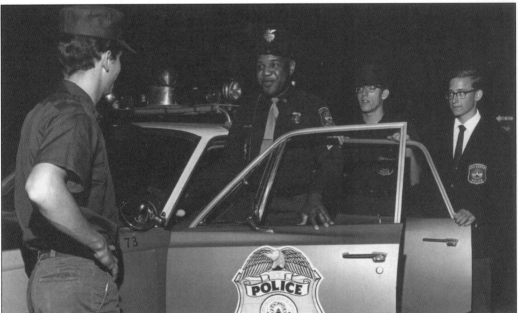

Eddie Owens became the Ann Arbor Police Department's first black detective. He rose through the ranks to become lieutenant detective. Owens joined the police force in 1953 as a highly decorated veteran of World War II. He continued his education in law enforcement at Washtenaw, Lansing, and Kalamazoo community colleges. He received many citations for his work with youth. He passed away in April 1996 after a long illness. (Courtesy Ann Arbor News.)

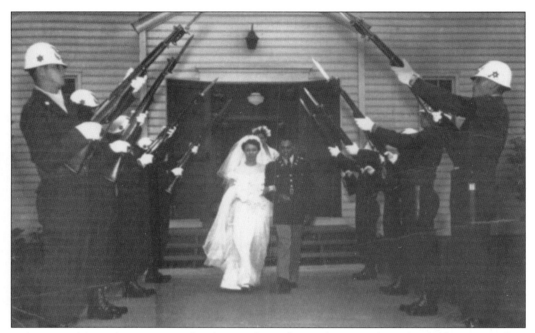

Military weddings became popular during the 1940s and 1950s when the draft was in effect and men were being called up for service with increasing frequency. At the end of the marriage ceremony ushers formed two lines and created an arch with their swords. The bride and groom passed under the arch into their new life as husband and wife. At the reception the cake was cut with a saber. (Courtesy of Robert Hunter.)

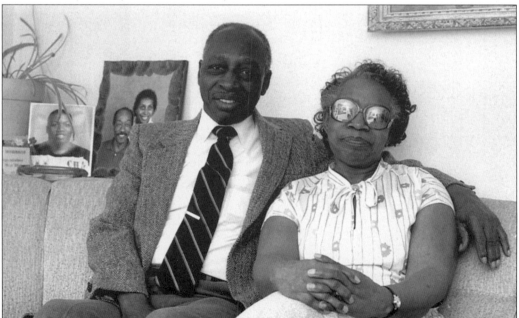

Lydia Morton, pictured here with her husband, John, is a descendant of two of Ann Arbor's oldest families, the Zebbs and the Cromwells. George Edward Cromwell of German and African descent married Lydia Zebbs of Dutch and African American descent. Members of the family were among the founders of Second Baptist Church. (Courtesy of Ann Arbor News.)

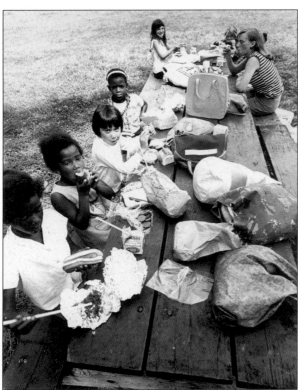

Children at Camp Tacoma are taking a lunch break near the lakeshore. At its height, the Dunbar Community Center purchased the former Girl Scout camp, which gave children an opportunity to have camping and other outdoor experiences. Many of the children learned to swim for the first time. (Courtesy of Ann Arbor Community Center.)

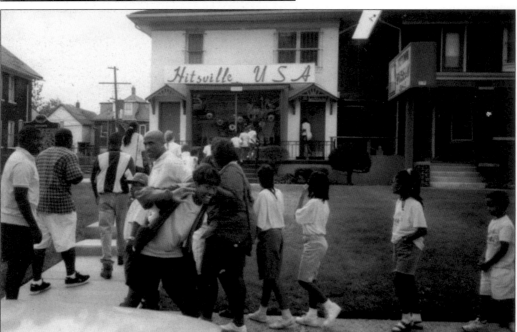

Children from the Ann Arbor Community Center enjoy a trip to the famous Motown Studio in Detroit. Every effort was made to enlarge the experiences of children who were often limited to local neighborhood activities. Field trips were one of the methods used to accomplish this goal. (Courtesy of Ann Arbor Community Center.)

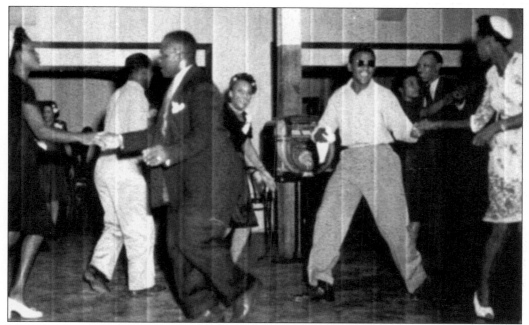

Black Ann Arbor had several venues for music or dancing. The Midway restaurant and the armory were two. A popular local band was founded by drummer John Harberd. His bandmates were John Sullivan, Frank Sleet, James Guster, George Overstreet, Herb Jones, James Etchinson, and Jimmy Anderson. They were the first black band to play at Barton, Whitmore Lake, and Dearborn Country Clubs and the University of Michigan and Eastern Michigan University. (Courtesy of Ann Arbor Community Center.)

The Komo Club on Greene Street was a place where people would go to hear big band music and socialize with friends. June Smith was the proprietor. The Greene Street area was a comfortable neighborhood where black people were able to enjoy a pleasant lifestyle from the 1940s to the 1960s. The club is now an apartment building. (Courtesy of Another Ann Arbor, Inc.)

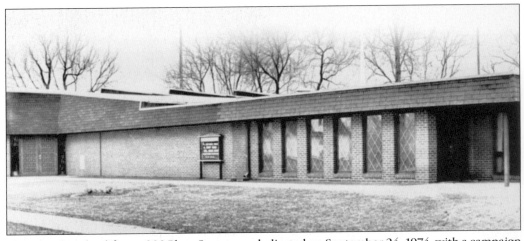

The new church edifice at 900 Plum Street was dedicated on September 24, 1974, with a campaign of Build a Better Bethel. The "BBB" campaign referred not only to the new church building but to all aspects of church life. A building committee consisting of James W. Anderson Jr., Dr. Roy Hudson, Rev. Silas McCarter, and William Brennan was appointed. The building was completed on schedule. (Courtesy of Another Ann Arbor, Inc.)

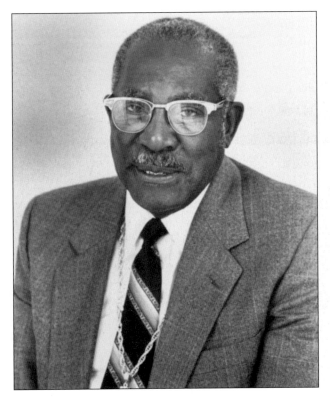

Rev. John A Woods was transferred to Bethel AME Church in 1964 and served for 25 years. Under his leadership a new church building was constructed. The church purchased adjacent property and established the Bethel Day Care Center. Plum Street was renamed John A. Woods Drive in his honor. The Rev. Joseph A. Cousins was assigned to the church in 2004. (Courtesy of John Woods Jr.)

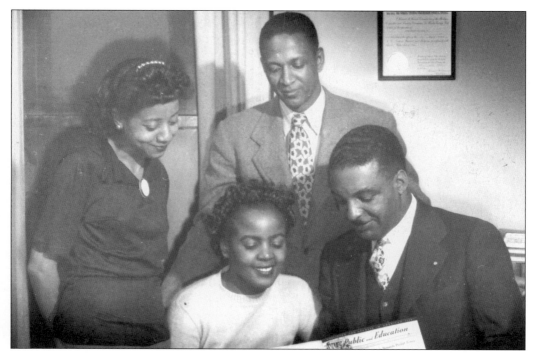

The staff of the Dunbar Community Center investigated new trends in educational programming. They developed plans for University of Michigan volunteers and others to participate in with the children after school and in the summer. Pictured in the front row are Virginia Ellis and Douglas Williams. In the back row are Flora Cherot and Benjamin Schobe. (Courtesy of Ann Arbor Community Center.)

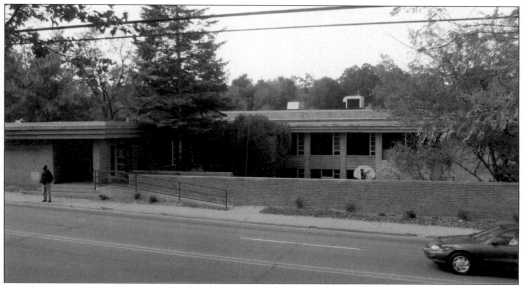

Under the direction of Douglas Williams, the Dunbar Community Center acquired a new name and address, the Ann Arbor Community Center, at 625 North Main Street. This newly constructed building was to serve the general community and would be supported in part by the city and the United Way. It housed a complete kitchen, playrooms for children, and meeting rooms. (Courtesy of Ann Arbor Community Center.)

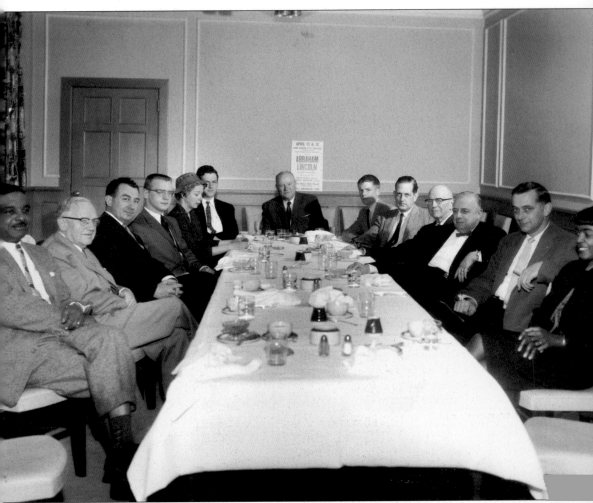

Douglas Williams worked well with the power structure. His calling card was the red apple he left if a person he wanted to see was not available. Doug, as he was affectionately called, was a problem solver. Through negotiation and persuasion he improved the quantity and level of employment available to African Americans. He was a goodwill ambassador moving between both communities. Williams was a member of many organizations and performed numerous works of service. Due to his many contacts and excellent reputation, he was able to persuade the city of Ann Arbor and the United Way to contribute to a new facility on North Main Street. Tragically, six months after the new building opened, Williams was found dead at his desk. He died of a heart attack, leaving a shocked community to grieve his death. (Courtesy of Ann Arbor Community Center.)

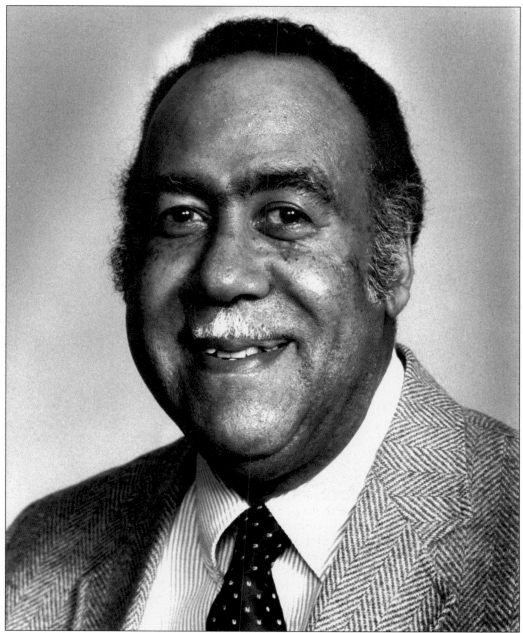

Walter Hill was executive director of the Ann Arbor Community Center from 1961 to 1991. He moved the focus of the center from primarily recreational to offering counseling services and community resources. In the 1970s, the center extended its service beyond the north-central neighborhood and reached out to other areas of the city. Hill established neighborhood clubs and voter education workshops. Program development became a priority for the Ann Arbor Community Center. Professional staff was hired, and University of Michigan social work students counseled there as part of their course work. The center established a licensed day care facility, a teenage drop-in center, and a study hall with university tutors. On the occasion of the center's 50th anniversary, Hill emphasized his commitment to keeping programming flexible and responsive to the needs of the community. (Courtesy of Walter Hill.)

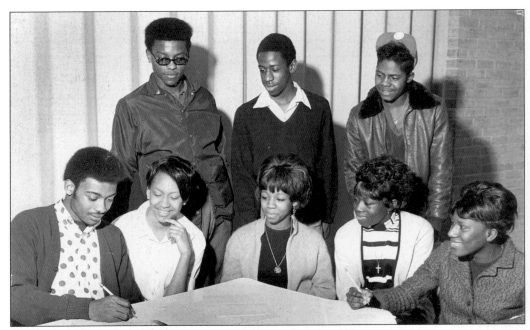

Active teenagers published a local newspaper called *Speakout* in 1968. Young people learned to take on projects that interested them with guidance from counselors at the center. Standing, second from the left, is Larry Hunter, future Ann Arbor City Council member from the First Ward. He seems to be getting experience for his future civic roles. (Courtesy of Ann Arbor Community Center.)

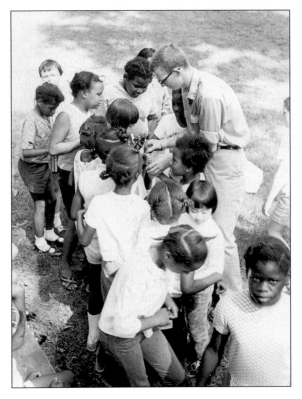

Children surround their counselor to learn more about a plant they have just found. A nature walk was part of the fun at camp as the children increased their awareness and curiosity about their environment. The activities introduced at the center were intended to have a learning component. (Courtesy of Ann Arbor Community Center.)

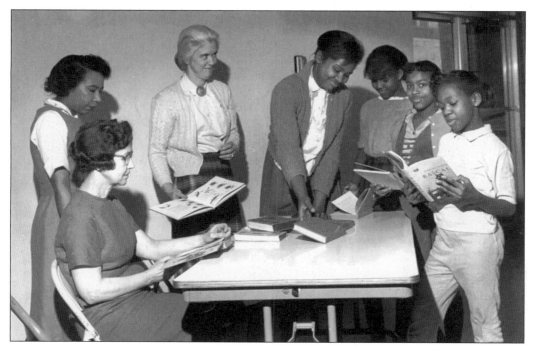

Volunteers Elgin Johnson, Posey Cobb, and an unidentified counselor assist youngsters as they plan their choices for a summer reading group. Reading for pleasure was one of the most popular activities encouraged at the center and enjoyed by the children as part of the programming, during the mid-1960s. (Courtesy of Ann Arbor Community Center.)

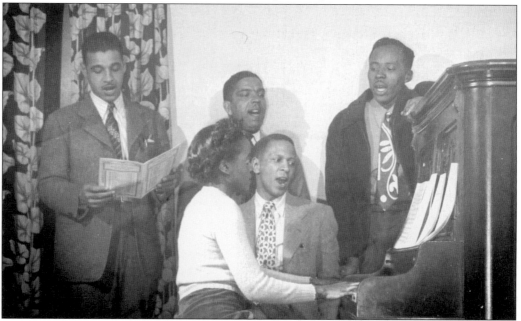

Virginia Ellis proved to be the catalyst for many of the activities at the Dunbar Community Center. She was an accomplished pianist and organized several choral groups there. Pictured are, from left to right, Herbert Ellis, Wesley Allen, James Anderson Sr., and Ben Schobe seated next to Virginia Ellis. (Courtesy of Ann Arbor Community Center.)

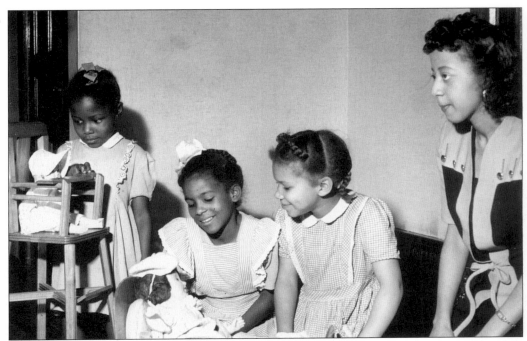

Little Bernadine Calvert and friends play with dolls as staff member Flora Cherot looks on. The Dunbar Community Center provided preschool, day care, and after school activities for working parents. The children are wearing pinafores to protect their clothing. Realistic black dolls were not available at that time. (Courtesy of Ann Arbor Community Center.)

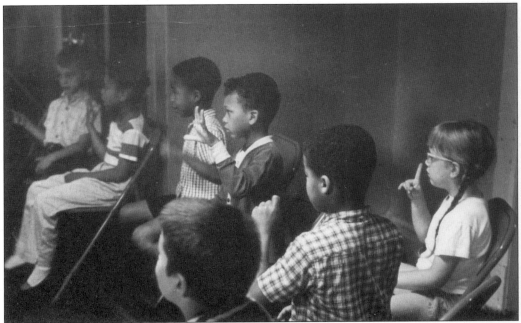

This integrated class being held at the Ann Arbor Community Center illustrates its new thrust to serve all of the Ann Arbor community, not any one segment. A 1960 article in the *Ann Arbor News* helped publicize this new emphasis. The center was located in a racially diverse neighborhood. (Courtesy of Ann Arbor Community Center.)

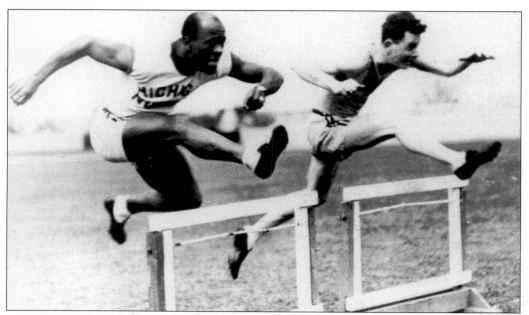

Eugene Beatty was fondly known as "Chief." He was an educator, an athlete, and a leader. As a student at Michigan Normal School (now Eastern Michigan University) in 1932, he was on the U.S. Olympic Track and Field team. In 1940, he was appointed principal of Harriett School, becoming the first full-time black principal in Michigan. He served in that capacity for 27 years before accepting other school assignments. Beatty also chaired the Ypsilanti Housing Commission. He received numerous community service awards. The Michigan State Senate presented a Resolution of Tribute to him for his outstanding record from 1940 to 1974. In 1985, he was admitted to the Michigan Education Hall of Fame. In 1989, a bronze bust of Beatty was erected in Perry Child Development Center and a cedar tree was planted on its grounds in his honor. (Courtesy of Ypsilanti Historical Museum Archives.)

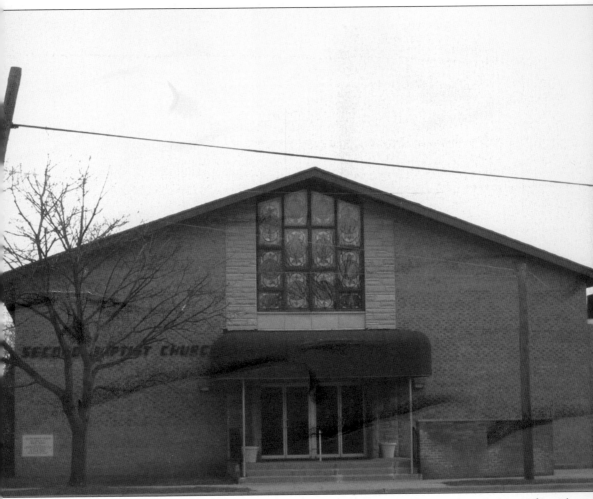

The Second Baptist Church, Ypsilanti, of 301 South Hamilton Street, was founded in 1860 with 11 members. The black congregation started out worshipping at the white First Baptist Church of Ypsilanti. After leaving the First Baptist Church, they bought the old Presbyterian Church by what is now Cleary College. They paid $1,200. Later they moved to Babbit Street between Park and Grove Streets. The congregation was then able to build its present structure with a seating capacity of 300 at Hamilton and Catherine Streets. The land on which the church now stands was deeded to Second Baptist Church by Charles Patterson of the First Baptist Church. The land was held in trust by the First Baptist Church until 1953. The Rev. Garther Roberson Sr. served as pastor for 20 years and oversaw rapid financial and spiritual development. The church has a history of strong missionary work. (Courtesy of Another Ann Arbor Inc.)

This was the home of the Second Baptist Church of Ann Arbor at 214 Beakes Street, from the early 1950s until a new structure was completed in 1980. Rev. Charles Carpenter served as pastor from 1929 until 1965. With his leadership, the church provided many services for people in the Ann Arbor community. Carpenter was an outspoken advocate for the poor. During the Depression of the 1930s, the church became a major relief agency for indigent people, both black and white. In 1945, the church celebrated its 100th anniversary with dignitaries from around the state in attendance. In 1968, Rev. Emmett L. Green succeeded Carpenter. Green served for 34 years. In 2002, Rev. Mark J. Lyons became pastor of the new Red Oak location. A child care center now occupies the Beakes Street building. (Courtesy of Another Ann Arbor Inc.)

Seen here is the versatile Coleman Jewett, retired school administrator and local historian. He is a familiar figure at the farmer's market on Saturday mornings, showing his enormously popular Adirondack furniture. He played on Michigan Normal University's basketball team and helped win a city championship in 1958. Jewett cowrote a children's book on Ann Arbor history called *Early Ann Arbor and Its People*. (Courtesy of Another Ann Arbor, Inc.)

Calvert's Roll-Off Container, Inc., of 7887 Jackson Road has been in business since the early 1950s. The company was started by Burgess Calvert with one truck. His oldest son, Russell, joined the company in 1976 and has greatly expanded the business to include government and commercial services. (Courtesy of Russell Calvert.)

Lucille Richardson, who was a mortician, established Lucille's Funeral Home in 1940. The establishment has served Ann Arbor and Ypsilanti blacks for over 60 years. Today the home, located at 411 South Adams Street in Ypsilanti, has been expanded and modernized by C and H Community Home for Funerals. It continues to be family owned. (Courtesy of Another Ann Arbor, Inc.)

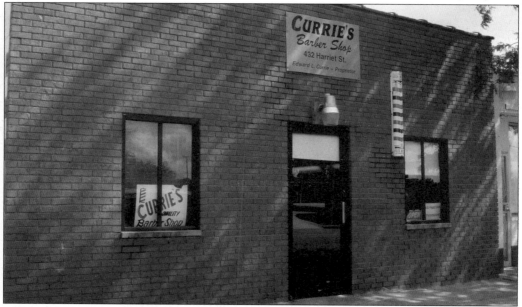

Currie's Barber Shop at 432 Harriet Street is one of Ypsilanti's few remaining businesses after urban renewal decimated black neighborhoods and the business community. Controversial federal programs, such as urban renewal, which were meant to rebuild decaying cities, often had the opposite effect. Harriet Street was lined with stores on the south side's black shopping district. Ed Currie's shop now faces the Parkview Housing complex. (Courtesy of Another Ann Arbor, Inc.)

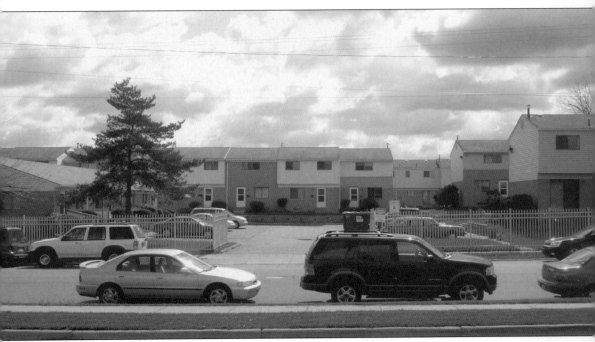

The Parkview Housing Complex was developed in 1970 through a partnership between the Housing and Urban Development (HUD) agency, Brown Chapel, and the Ann Arbor/Ypsilanti Negro Business and Professional League. Its purpose was to provide affordable housing for low-income people. The complex has 144 units. Dr. Thomas Bass was Parkview's first board president. This project became one of the important aspects of his community service. He served as board president for 20 years. Dr. Bass came to Michigan to attend the School of Public Health. After graduation, he was persuaded to stay and practice in Ypsilanti. As a believer in public service, Dr. Bass became a trustee of Brown Chapel and served as president of the NAACP. He was a founding member of the Ypsilanti Boys Club and was a member of the Ann Arbor/Ypsilanti Negro Business and Professional League. (Courtesy of Another Ann Arbor Inc.)

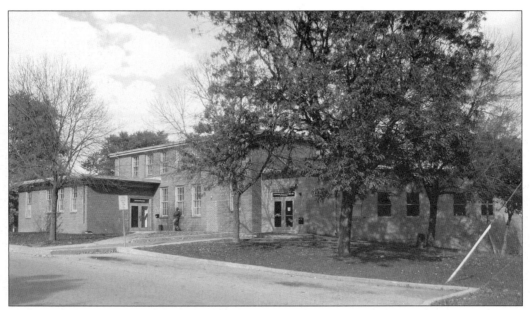

The Parkridge Community Center, a mainstay of the Ypsilanti community for over 60 years, is located on the city's south side. In its heyday, it provided free recreational, health, and cultural activities for youth under 18 years old. An active teenage youth board, after school sports, and resources for older adults were an important part of the agenda. (Courtesy of Another Ann Arbor, Inc.)

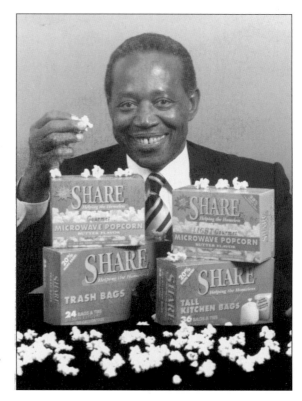

In this photograph, John Barfield is displaying items from Share Products, one of his many business enterprises. Profits from the sale of these products were designated to help the hungry and the homeless. He has had four successful businesses in Ypsilanti, allowing him to give back to the community. Additionally Barfield raised millions for the United Negro College Fund. Today he is chairman emeritus of the Bartech Group, the nation's largest independent staffing company. (Courtesy of John Barfield Sr.)

DeLong's BarbQ Pitt was a favorite spot from 1964 until 2001. Situated across from the Ann Arbor farmer's market, DeLong's carryout restaurant was usually crowded. Owner John Thompson says the name DeLong's comes from his Jones School gym teacher who gave him that nickname. He was the tallest student in the class and the name stuck. He and his wife, Adeline, ran the restaurant together for 37 years. (Courtesy of John Thompson.)

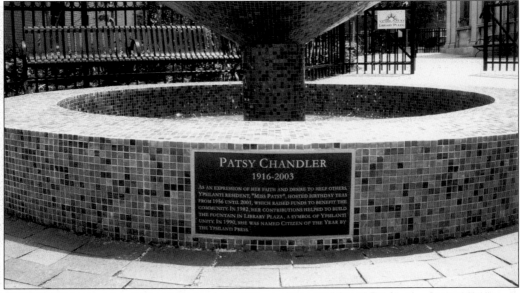

The inscription on this beautiful mosaic tiled fountain reads "Patsy Chandler 1916-2003. As an expression of her faith and desire to help others Ypsilanti resident 'Miss Patsy' hosted Birthday teas from 1952 -2001 which raised funds to benefit the community. In 1982 her contributions helped to build this fountain in Library Plaza, a symbol of Ypsilanti unity. In 1990 she was named Citizen of the Year by the Ypsilanti Press." The fountain is on Michigan Avenue in Library Park. (Courtesy of Ypsilanti District Library.)

Three

STRUGGLES FOR EQUITY

Washtenaw County became a center of leadership in the struggle for equity. The major challenges of the time were inadequate housing due to segregation, inadequate educational opportunity, and a lack of political representation.

Black people were forced to live primarily in north-central Ann Arbor. Others lived in Lower Town and the Woodlawn area near Packard. In Ypsilanti, blacks settled on the south side of town off Michigan Avenue. The NAACP and the Congress on Racial Equality (CORE) began to push for equal housing. After a long struggle, the Ann Arbor city council enacted the first fair housing ordinance in the state of Michigan. Families were able to purchase homes in any area they could afford.

In response to the 1954 *Brown v. Board of Education* Supreme Court ruling, the Ann Arbor Board of Education decided in 1966 to close Jones School, where most black children were educated. The children were bussed to five elementary schools around the city. Ypsilanti responded differently. Instead of closing Perry Elementary, they sent all children from kindergarten through third grade there.

The famous Black Action Movement (BAM) strike of March 19, 1970, played a pivotal role in Washtenaw County history. The students' motto was "Open it up or shut it down." Their protest closed most of the University of Michigan for the first time in its history. As a result of the actions of the black students and their like-minded allies, a compromise was reached that brought more black and minority students and faculty to the campus.

African Americans were also making advances politically in Washtenaw County. Richard Dennard was elected to the city council in 1957. He was followed by Larry Hunter. John Burton was the first African American elected mayor of Ypsilanti in 1967. This was followed by the election of Albert Wheeler as mayor of Ann Arbor in 1975.

Letty Wickliffe was born in Ann Arbor in 1902. Her father was an escaped slave who joined the Union Army. After the war, he came to Ann Arbor where he met and married Mary Jewett Wickliffe. Letty was one of only six black women to graduate from the University of Michigan in 1926. While there, she cofounded the Nu Chapter of Delta Sigma Theta Sorority, Inc. The Ann Arbor schools would not hire a black teacher, so she went to Texas to teach. Later she established a high school program for gifted students in Indiana. Upon retirement in 1986, she returned to Ann Arbor. An avowed Republican, she became influential in civic affairs. Wickliffe was president of the North Central Property Owners Association. As a member of the Ann Arbor Planning Commission, she successfully opposed urban renewal. She felt it would destroy the black neighborhood. Wickliffe died in 2001 at 99 years old. (Courtesy of Bentley Historical Library.)

Emma Wheeler, a lifelong Democrat, came to the University of Michigan in 1938 to do graduate work. She married Albert Wheeler, a student in the School of Public Health. She was president of the NAACP from 1957 until 1973. Her emphasis was on improving housing conditions for blacks in Ann Arbor. She organized a home tour of substandard housing to give visibility to the situation. The tour coincided with the tour of beautiful homes, which took place each year. She organized a march in front of city hall in support of a fair housing act. Largely as a result of her efforts, in 1965, Ann Arbor became the first city in Michigan to adopt a fair housing act. It forbade discrimination in the sale or renting of homes. Both Wheeler and her husband were instrumental in improving conditions for blacks in the city. (Courtesy of Ann Arbor News.)

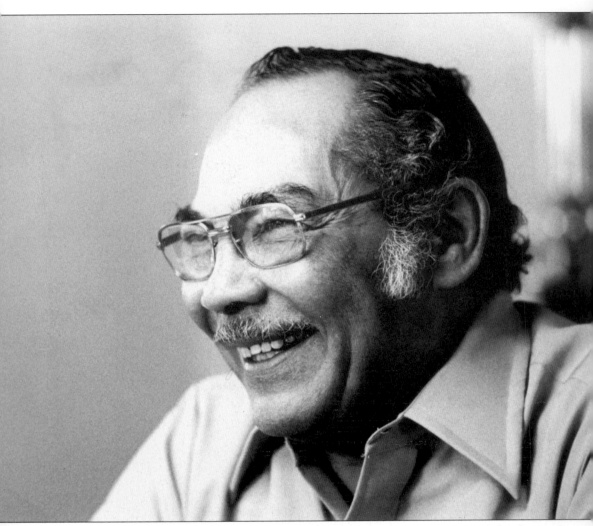

In 1975, Dr. Albert Wheeler, a University of Michigan professor, was elected Ann Arbor's first and only black mayor. Wheeler received a doctorate from the University of Michigan in 1944, and in 1953, became the first black tenured professor at the University of Michigan Medical School. He joined the Ann Arbor Civic Forum and turned it into a powerful political force. In 1954, he helped revive the local chapter of the NAACP, which had been dormant for many years. In the early 1950s, working through the NAACP, his agenda included education, employment, and human rights. The civil rights provision in the state constitution is attributed to his efforts. In the 1970s, Wheeler and the NAACP were instrumental in establishing Ann Arbor's federally funded Model Cities Program. The program provided services, including low-cost child care, dental care, legal counsel, and health care, to poor clients. (Courtesy of Ann Arbor News.)

Working out of this building on Detroit Street in the 1960s, Thomas Harrison became the first black licensed real estate agent in the county. Prior to this, blacks were only shown houses in "colored neighborhoods." This restricted the number and location of houses open to blacks. Harrison would sell one house on a block, and suddenly other houses on the street would become available. For this reason he was sometimes called the "Blockbuster." (Courtesy of Another Ann Arbor, Inc.)

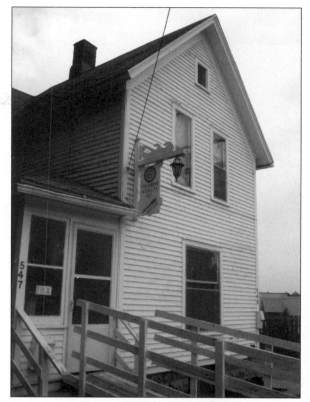

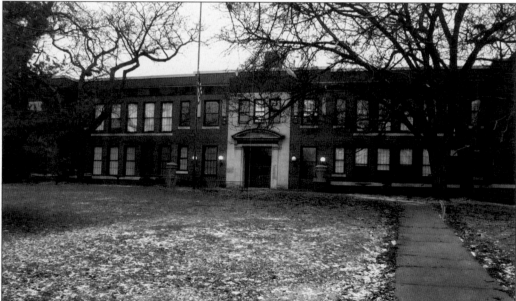

In 1966, the Ann Arbor Board of Education voted to close Jones Elementary School, located on Division Street, and bus the children to five elementary schools around the city to achieve racial balance. Jones Elementary had been the neighborhood school for generations of black children. It was generally believed that the children would receive an improved education in the integrated schools where resources were better. (Courtesy of Another Ann Arbor, Inc.)

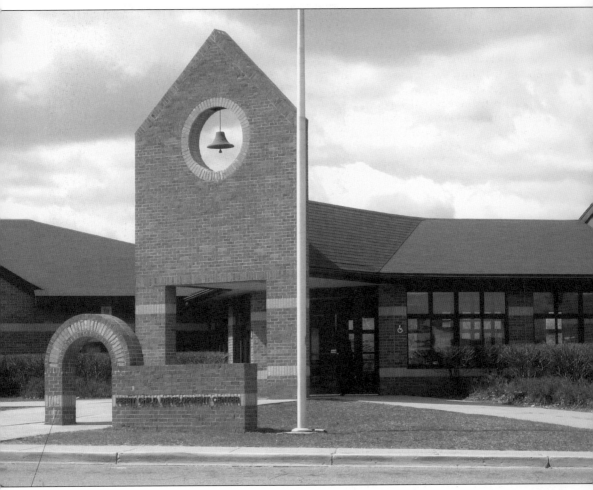

Perry Child Development Center in Ypsilanti is named for Dr. Lowell C. Perry, the first black dentist in the area and the first black member of the Ypsilanti Board of Education. Because his passion lay in helping youngsters achieve, the Perry Child Development Center was named in his honor after his death. The center is part of the Ypsilanti School District and houses all preschool through second grade classes as well as a literature academy. Harriett School, originally named Adams School, was the traditional neighborhood school, which most black children attended. When the U.S. Supreme Court mandated the end to segregated schools, the decision was made to bus all young children to one central school, which was Perry. This was in sharp contrast to what many other cities decided when they bussed only black children to obtain racial integration. (Courtesy of Another Ann Arbor Inc.)

Harry Mial was an educator and a civil rights advocate. He was Ann Arbor's first black teacher in 1954. When the school district claimed that it could not find any qualified administrators, Mial challenged the system. He opened doors for others for decades to come. Mial served the Ann Arbor Public Schools for 32 years as a teacher, principal, and administrator. (Courtesy of Dr. Joetta Mial.)

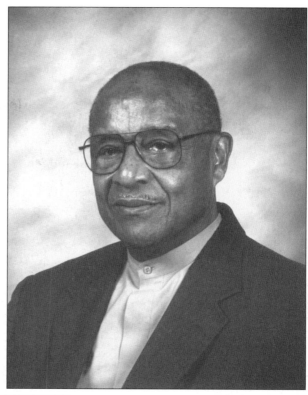

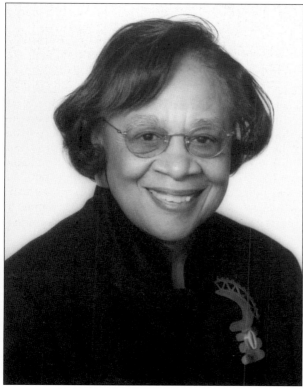

Joetta Mial became Huron High School's first black and first female principal in 1987. She started out as a "come-back mom" who returned to college after her three sons were in school. She received her bachelor's, master's, and doctorate degrees from the University of Michigan. She retired in 1994 and is active in many organizations. (Courtesy of Dr. Joetta Mial.)

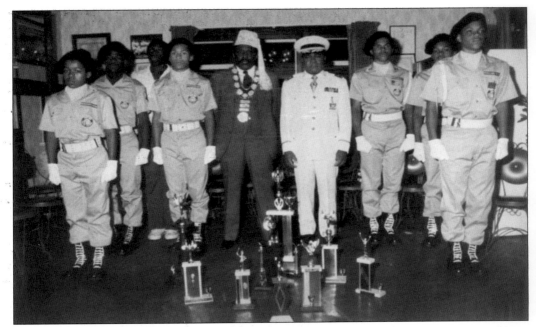

The Elks Pratt Lodge formed the French Dukes Precision Drill Team in 1962 to give teenaged boys discipline and a structured activity. The drill team won every state and national competition they entered. They performed spectacular steps for thousands of spectators. In 1972, the French Dukes performed in Pres. Richard Nixon's inaugural parade. (Courtesy of William V. Hampton.)

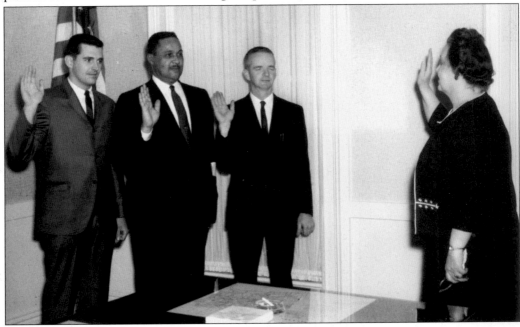

John Burton rose through the ranks of the United Auto Workers Union (UAW) to become Ypsilanti's first black mayor in 1967. He served on Eastern Michigan's Board of Regents, the executive board of the United Way, and the Washtenaw County Board of Supervisors. Eastern Michigan University established and endowed a scholarship in his name for his dedicated service to the community. (Courtesy of Ypsilanti Museum Archives.)

George Goodman was Ypsilanti's second black mayor. Appointed in 1972, he won the next four general elections. He is the longest-serving mayor in Ypsilanti history. During his tenure, he oversaw the building of the Towne Center Place at 410 West Michigan Avenue, the Jesse Rutherford Swimming Pool, and the city hall move to Michigan Avenue. In 1983, he resigned to become director of the Michigan Municipal League in Ann Arbor. (Courtesy of Ypsilanti Historical Museum Archives.)

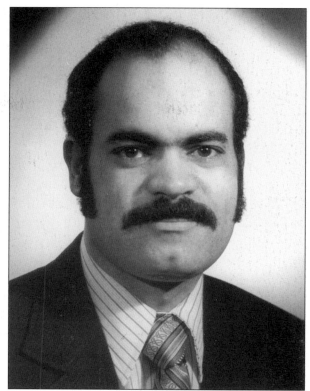

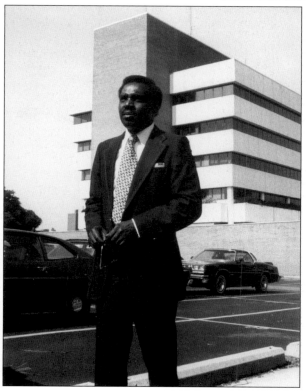

Pictured here is Sylvester Murray who, at age 32, became Ann Arbor's first black city administrator. He served from 1975 to 1981. With degrees in American history, government administration, and economics, Murray was known for his effective budgets, administration, and management. Later Murray became recognized nationally for his work in Cincinnati and San Diego. From his base at Cleveland State University, Murray has focused on consulting and training minorities for government careers. (Courtesy of Ann Arbor News.)

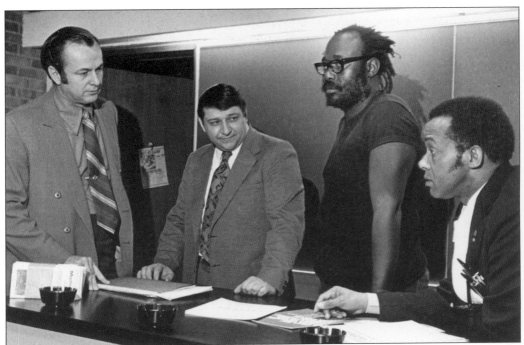

Representative Raymond Smith, Robert Breault, Charles Thomas, and David Byrd (from left to right) consult on the social issues presented by Thomas. Thomas, an imposing figure, confronted church congregations with a black manifesto of demands in the 1960s and 1970s. His concern was for economic development, welfare rights, and affordable housing. (Courtesy of Bentley Historical Library.)

Charles Thomas founded the Washtenaw County Black Economic Development League, whose headquarters are located at 340 Depot Street. Here black youths were taught computer technology, computer repair, television repair, and photography. Thomas also explored the potential of solar energy. He received several awards for his work with young people, and a scholarship at Washtenaw Community College was established in his name. Thomas died in August 1994 at the age of 56. (Courtesy of Another Ann Arbor, Inc.)

David Byrd worked with Charles Thomas to set up a program for black youth to learn the construction and rehabilitation of houses. Byrd, an architect, initiated and conducted the student construction program at Washtenaw Community College. Byrd also designed three churches in the area and served as a Washtenaw County Commissioner. (Courtesy of Letitia Byrd.)

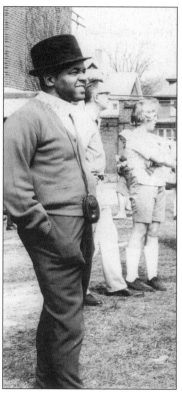

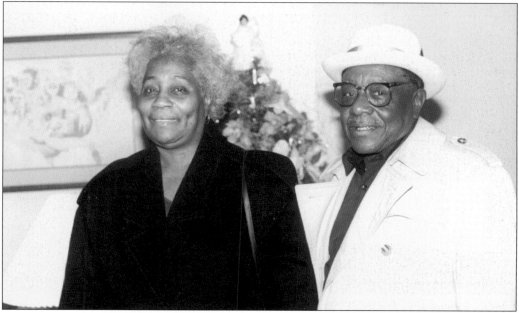

As one of 14 children, Ezra Rowry grew up in extreme poverty in Mississippi. He moved to Ann Arbor in 1951. No stranger to discrimination, he found plenty of it in Ann Arbor in the 1960s and 1970s and was a fiery proponent of the civil rights movement. He became chairman of the Ann Arbor branch of CORE and a member of CORE'S national board of directors. (Courtesy of Ezra Rowry.)

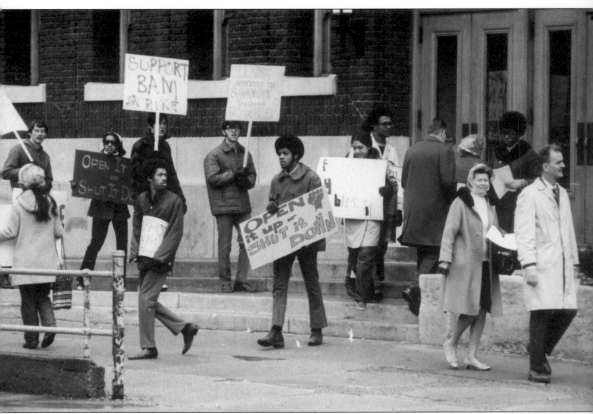

In 1970, a coalition of black students called the Black Action Movement (BAM) urged all students at the University of Michigan to boycott classes to enforce demands for increased black enrollment. They argued that the university should reflect the population of the state. The students, joined by many white and other minority supporters, obstructed the doors to Angel Hall and Hill Auditorium. "Open it up or shut it down" was the rallying cry. The black students initially brought their concerns to the administration. When no action was taken, they decided on the strike. The strike continued for 13 days. Although there was no official dismissal of classes, most students and many instructors refused to cross the picket lines set up by the black students. The most crucial support came when the unions who delivered food to the dormitories and restaurants on campus refused to cross the black students' picket lines. (Courtesy of Bentley Historical Museum.)

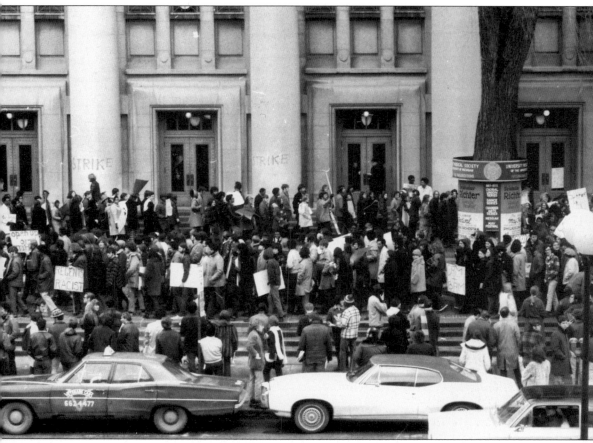

The 1970 BAM strike was the first time that major departments in the University of Michigan were shut down. Eventually Pres. Robin Fleming and leaders of BAM met and opened talks. Students wanted more blacks admitted to the university. The administration agreed to a goal of a 10 percent increase in black enrollment, increases in overall minority enrollment, an academic support office, and the establishment of a new department. Out of BAM came the Center for African American Studies (CAAS), the Opportunity Program, a counseling and support service for minority students, and the William Monroe Trotter Multicultural Center. A liaison for Minority Affairs was also established. A second BAM strike was held in 1975 and a third in 1987 to try to force the university to honor its original pledge regarding black enrollment. In 1987, Dr. Charles Moody became the university's first vice provost for minority affairs. While minority enrollment increased, 10 percent black enrollment has never been achieved. (Courtesy of Bentley Historical Library.)

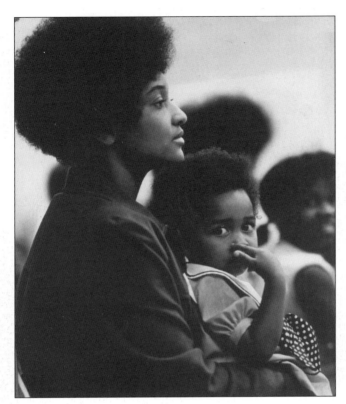

Mother and daughter are wearing the trendy Afro hairstyle of the period. Hairstyles took on a political connotation during the civil rights era. Blacks who wore their hair straight were considered to be more conservative than those who adopted the fashionable Afro hairstyle. (Courtesy of Dunbar Community Center.)

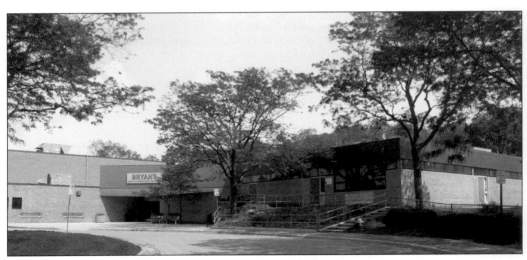

Bryant Elementary School was opened in 1973. The school was named after Clifford E. Bryant, an extraordinary man who was a friend to students and teachers. He always wanted to be a teacher, but when his mother died he had to quit school. He found employment as a custodian at Ann Arbor High School in 1946. After many years, he transferred to Bryant, where he remained until his retirement 1971. (Courtesy of Another Ann Arbor, Inc.)

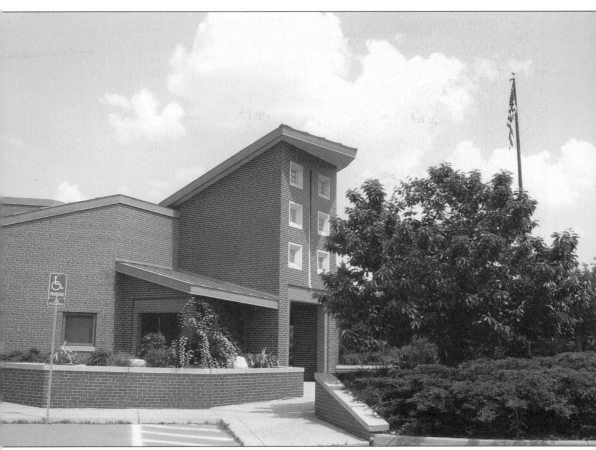

In 1974, the Roberto Clemente Development Center was established as an alternative school for troubled youth. Joseph Dulin, an educator from Detroit, was offered the position of principal. Originally the school was called the Alternative School for Disruptive Youth, but Dulin insisted on a name change. It was renamed Roberto Clemente after the famed Puerto Rican baseball star and humanitarian. The school believes in respecting children. In 1994, the school moved into the new state-of-the-art facility pictured here. In 1996, Dulin began the National African American Parent Involvement Day (NAAPID). This is an organization designed to encourage parents to get involved in their children's education. Parents are invited to come to school on a specific day and find out what is being taught. In the first year of the program, schools in 40 states participated. NAAPID is an organization designed to address the serious achievement gap facing African American students. The day is one strategy to accomplish this end. The second Monday in February annually is designated as National African American Parent Involvement Day. (Courtesy of Another Ann Arbor, Inc.)

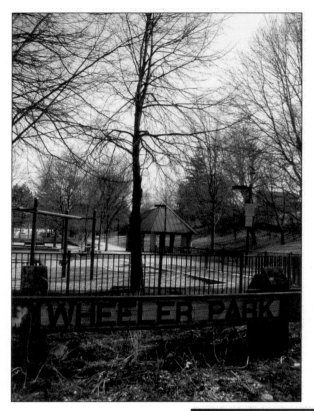

Wheeler Park is located on Depot Street, across from the train station in the heart of the old black neighborhood. The land, bounded by North Fourth Avenue, Summit Street, and North Fifth Avenue, had been owned by the city for years. It had been leased to Lansky's Junk Yard and to Peter's Slaughterhouse and Sausage Plant. In the mid-1970s, under pressure from nearby residents who felt the land use was incompatible for their neighborhood, the area was cleared and made into the park. On January 21, 1987, the Ann Arbor City Council voted to change the name of Summit Park to Wheeler Park in honor of former mayor Albert Wheeler. The multiuse park is enjoyed by youngsters on swings, teenagers at the basketball hoops, and adults holding festivals and special events. (Courtesy of Another Ann Arbor Inc.)

Fredrick and Norma McCuiston revived the Ann Arbor chapter of the NAACP after 10 years of inactivity. Their goal was to give voice to the needs of blacks in the city. They successfully generated interest in the areas of employment opportunities, educational issues, and housing. Dr. Harry Williams moved the programs forward. Later William Hampton took up the task. Programming included a Freedom Fund Dinner, student tutorials, and a Juneteenth Celebration. (Courtesy of Fredrick McCuiston.)

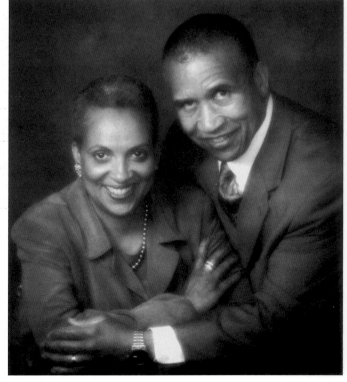

Four

TAKING STOCK, CELEBRATING SUCCESSES

This final chapter reflects on Washtenaw County as it is today with a strong body of high-achieving African Americans, including several top officials at the universities; in the public school systems; in politics, city government, and law enforcement; and in all aspects of community life. There are successful businesses in automobile dealerships, financial institutions, industry, and entrepreneurship. Throughout the county, African Americans are supporting young people through tutoring, scholarship, mentoring, and advocacy. From the award-winning Morris Lawrence Afromusicology genre and the Sphinx Organization's internationally successful classical music competition, to the nationally known Willis Patterson Chorale, engaging, innovative collaborations are incubated here. Prominent black scientists, like the late physicist Dr. Willie Moore, the preeminent particle physics researcher Dr. Homer Neal, and leading alternative fuel cell scientist Dr. Levi Thompson have all made their mark from Ann Arbor. This area's nationally known athletes have moved on from the college stage to make major contributions to society. African Americans are well represented in the health care systems in both Ann Arbor and Ypsilanti. Have African Americans in Washington County "arrived"? No, but they are better positioned to meet the challenges that are still present. Gone but well remembered are certain images that briefly crossed the scene: the Cafe Creole on North Main Street and Catherine Street, the Caribbean Kitchen on Packard Street, the Ypsilanti Seafood on Michigan Avenue, Ypsilanti, the Blair-Shaw Women's Boutique on Main Street at Washington Street, and the Medina on Maynard Street.

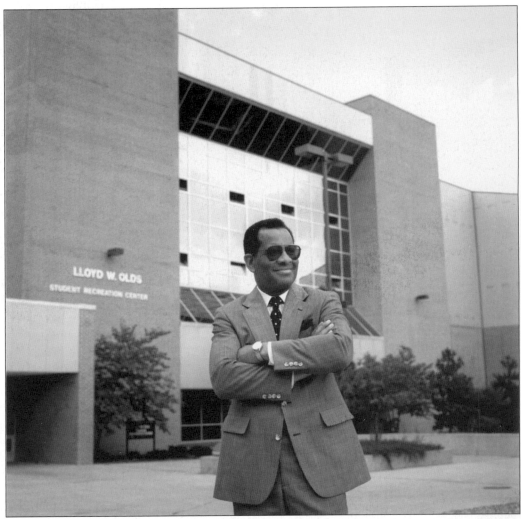

In 1980, John Porter became Eastern Michigan University's first black president. He was born in Fort Wayne, Indiana, on August 13, 1931. He received a master's degree in counseling and a doctorate in higher education from Michigan State University. In 1969, he became the youngest and the first black state superintendent of schools in the United States. During his nearly 10 years as president, enrollment at Eastern Michigan University increased 28 percent. He created the state's first college of technology, setup a task force on minority affairs, and increased the university's emphasis on international and corporate education. A $6 million corporate education building was constructed under his leadership. After a successful administration, on January 1, 1989, Porter announced his intention to resign the presidency to seek a position in the private sector. (Courtesy of Eastern Michigan University.)

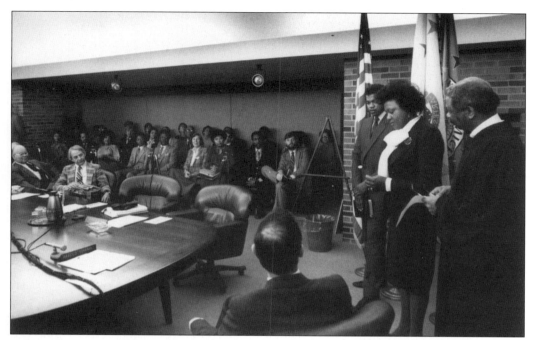

In this photograph, Nellie Varner is being sworn in as the first African American to serve on the University of Michigan's Board of Regents. She cochaired Lee Bollinger's presidential search committee and strengthened affirmative action and opportunities for women. Varner served from 1980 to 1996. She was also an associate professor of political science as well as dean of the Rackham School for Graduate Studies. (Courtesy of Ann Arbor News.)

Rev. Emmett L. Green served as pastor of the Second Baptist Church of Ann Arbor from 1968 to 2002. He moved the church from 214 Beakes Street to 850 Red Oak Street in 1980. The new building gave the congregation the opportunity to grow and to expand its ministry. Reverend Green became pastor emeritus, and Rev. Mark J. Lyons became pastor in 2002. (Courtesy of Another Ann Arbor, Inc.)

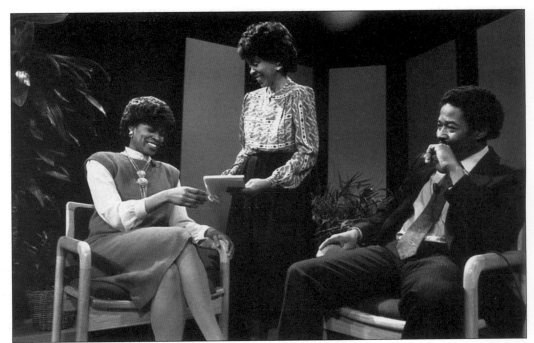

Host Carol Gibson and producer Lola Jones discuss the program while guest Peter Yelorda, executive director of Washtenaw County's Community Services Agency, waits for the show to begin. The Another Ann Arbor series interviewed people who were making a positive impact in the black community. The television show aired on WIHT (Channel 31) for 11 years. (Courtesy of Ann Arbor News.)

The sign reads "Blake Transit Center." The center is across the street from the downtown library on Fifth Avenue in Ann Arbor. Richard Blake worked as a bus driver, supervisor, and manager of information for the downtown center, and finally coordinator of marketing for the company. After his death in 1989, the board named the center after Richard Blake, who had been a long-standing and well-respected part of the organization. (Courtesy of Another Ann Arbor, Inc.)

Jones and Stewart Family Dentistry is located at 2390 South State Street in Ann Arbor. Both are graduates of the University of Michigan School of Dentistry. The practice was established by Dr. Lee W. Jones in 1963. For 25 years, Dr. Jones served as director of minority affairs at the University of Michigan Dental School. An endowed scholarship is named in his honor. Karen Jones Stewart, D.D.S., M.S., joined the practice in 1994. (Courtesy of Another Ann Arbor, Inc.)

This is the second home of the Anderson Associates at 2160 South Huron Parkway. The business was established in 1991. James Anderson Jr. has been in real estate for 29 years. He was vice president and general manager of the largest real estate company in the city before starting his own business. (Courtesy of James Anderson.)

Brown Chapel built a new edifice at 1043 West Michigan Avenue in 1999. The church continues its outreach ministries with the Silver Club, a support group for people suffering from Alzheimer's, a child care center, and other beneficial programs. The church holds an annual Brotherhood Banquet. This affair attracts outstanding speakers and helps to hold together a racially diverse community. The longstanding Reverend Jerry Hatter is pastor. (Courtesy of Another Ann Arbor, Inc.)

Lucille Porter is a longtime Ann Arbor resident and a graduate of the University of Michigan. In 1983, she founded the Community Leaning Post at 911 North Fourth Avenue. The organization offers services to unemployed and low-income families. Its current emphasis is on males under 18 years of age. Students from the University of Michigan and Eastern Michigan University provide mentoring and tutoring. (Courtesy of Lucille Porter.)

Each year the Community Leaning Post sponsors the African American Downtown Festival Celebration to commemorate the fellowship that existed between the north-central neighborhood and black businesses. People from all over the country come back to reunite with classmates and neighbors. The first African American Downtown Festival Celebration was held in June 1996. (Courtesy of Ann Arbor News.)

The African American Downtown Festival Celebration is held on Fourth and Ann Streets, near the old Kayser Block Building. It celebrates and commemorates Ann Arbor's black business district. On this day, local vendors help recreate the bustling business district that existed here at one time. Games, food, arts and crafts, and entertainment are the backdrop for socializing during the reunion. (Courtesy of Matt Souden.)

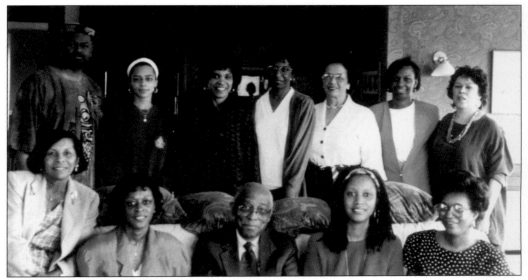

Pictured are the some of the founding members of the African American Cultural and Historical Museum of Washtenaw County. This nonprofit began in 1993 to increase awareness of past and present-day aspects of African American life. The museum presents programs and exhibits on black culture, including a tour of the Underground Railroad. Seated, front and center, is Dr. Charles Wright, founder of the Charles H. Wright Museum of African American History in Detroit. (Courtesy of African American Cultural and Historical Museum of Washtenaw County.)

Ypsilanti author and historian A. P. Marshall speaks at a 1993 program of the African American Cultural and Historical Museum in the Morris Lawrence building, Washtenaw Community College. Marshall moved to Ypsilanti in 1969 to become the director of Eastern Michigan University's library. In 1993, he published *Unconquered Soul: The History of the African American in Ypsilanti*. His papers are housed in the Ypsilanti Historical Museum and Archives. (Courtesy of African American Cultural and Historical Museum of Washtenaw County.)

Jon Onye Lockard is a founding faculty member of the University of Michigan's Center for Afroamerican and African Studies, and instructor at Washtenaw Community College. Lockard is a renowned artist specializing in African and African American art. He has held key positions in diverse cultural organizations, including artistic advisor for the Martin Luther King Monument in Washington, D.C. Lockard was the first black exhibition artist at the original Ann Arbor Art Fair. (Courtesy of African American Cultural and Historical Museum of Washtenaw County.)

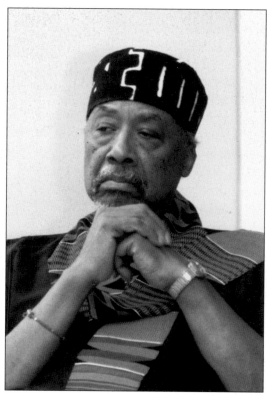

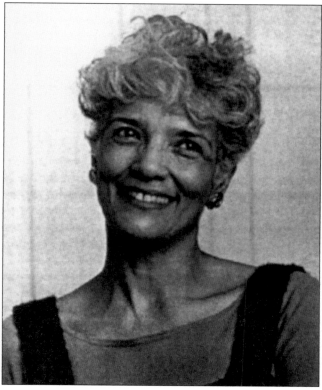

Vera Embree joined the University of Michigan as a dance professor in 1968. She taught modern and African dance and choreographed major works for the school's annual concerts. Previously she founded the Contemporary Dance Company of Detroit where she helped shape major choreographers. Embree was interim director of the School of Dance before retiring as professor emeritus in 1986. Two scholarships are given in her name. (Courtesy of University of Michigan School of Dance.)

The inscription on the Morris Lawrence building says, in part, "Washtenaw Community College wishes to celebrate and memorialize the contributions of this very extraordinary man and to permanently keep all those associated with the college aware of the values and commitment expressed with such caring and love by Dr. Lawrence during his lifetime. (Courtesy of Another Ann Arbor, Inc.)

Pictured here playing at an African American Cultural and Historical Museum function is Dr. Morris Lawrence. Lawrence was the director of Washtenaw Community College's Music Department and the music director of the Washtenaw Community College jazz band. He built the college's program from the beginning and with his students, earned an international reputation for the college. He was also a composer in his own right. He died suddenly in 1998. (Courtesy of African American Cultural and Historical Museum of Washtenaw County.)

Eager local children participate in tryouts for parts in the Ann Arbor production of the *Harlem Nutcracker* in 1996. The musical is an African American version of the *Nutcracker* ballet by Tchaikovsky. Donald Byrd's the *Harlem Nutcracker* was co-commissioned by Donald Byrd and the University Musical Society. The show was performed, in part, by the Willis Patterson Our Own Thing Chorale. (Courtesy of University Musical Society.)

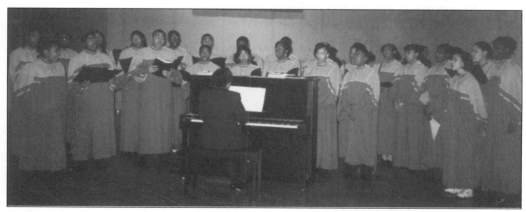

The Bethel AME Junior Choir sings in the lobby of the Power Center. They are led by choir director Francetta Ampey in December 1996, during the intermission of the popular Christmas musical, the *Harlem Nutcracker*. The event was arranged by Another Ann Arbor, Inc., affording children an opportunity to perform at the Power Center. (Courtesy of University Musical Society.)

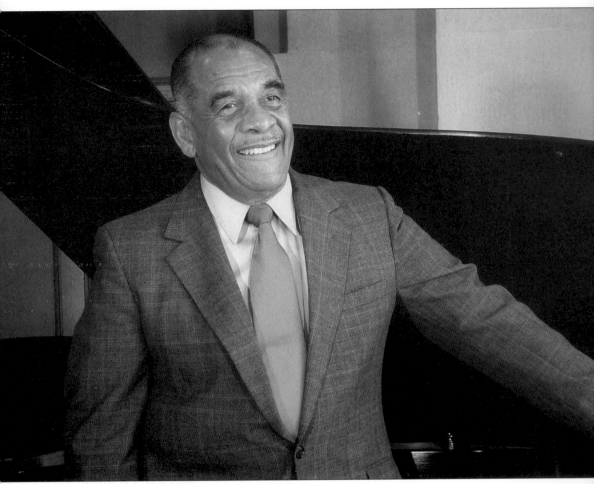

Dr. Willis Patterson is professor emeritus of the University of Michigan School of Music and founder of the Willis Patterson Our Own Thing Chorale. Born in Ann Arbor in 1930, he attended Jones School and graduated from Ann Arbor High School. After serving in the air force, Patterson earned his bachelor's degree and master's of music degree from the University of Michigan. He received his doctorate from Wayne State University and was a Fulbright Fellow. Patterson joined the University of Michigan School of Music in 1968. He served as a professor of voice, conductor of the men's glee club, and associate dean for academic affairs. Patterson has traveled Europe extensively appearing as a bass soloist with many major American orchestras. He appeared in an NBC-TV production of *Amal and the Night Visitors*; Gershwin's *Porgy and Bess*; Puccini's *La Boheme*, and many other roles. Patterson has provided free voice lessons to promising Ann Arbor youth for over 30 years. He has also served as chair of the African American Endowment Fund. (Courtesy of Willis Patterson.)

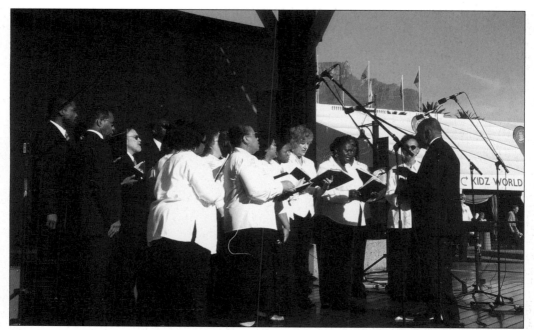

The Willis Patterson Our Own Thing Chorale is seen here performing in South Africa. Directed by Dr. Willis Patterson, they are a multigenerational, ethnically diverse, award-winning chorus. They have become a significant and valued institution in the area. The chorale places priority on the performance of African American music. They have performed locally, nationally, and internationally. (Courtesy of Willis Patterson.)

The Bird of Paradise, a popular Ann Arbor jazz spot, was considered one of the best in the nation. The intimate club took its name from a Charlie Parker tune. Opening in May 1985 at 209 South Ashley, "the Bird" jammed for almost 19 years. Dizzy Gillespie played there, as did the Count Basie Orchestra, Marcus Belgrave, Betty Carter, Shirley Horn, Mose Allison, Jeff Hamilton, Dee Dee Bridgewater, and many others. (Courtesy of Bev Willis.)

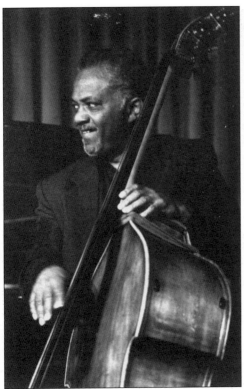

Ron Brooks, an Eastern Michigan University and University of Michigan graduate, is a self-taught bass player with a national reputation. He recorded with the Bob James Trio, which was produced by Quincy Jones. He also toured Europe with Duke Ellington and jammed with Sarah Vaughn and Mel Torme. Brooks's Bird of Paradise jazz club was voted one of the best in the nation. It was unique because it showcased local, national, and legendary acts together. The Brooks Trio was the house band. (Courtesy of Bev Willis.)

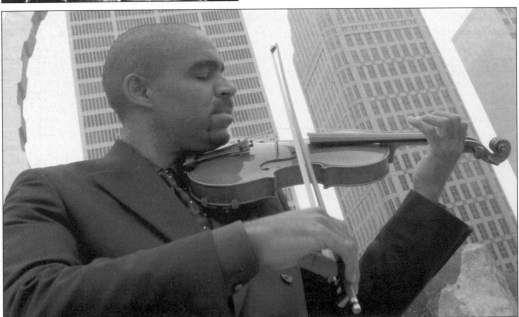

Aaron Dworkin began playing the violin when he was five years old. He attended the University of Michigan School of Music and heard a black composer for the first time. Dworkin made it his mission to diversify American symphonies. He founded the Sphinx Organization, whose purpose is to attract black and Hispanic students to classical music. It sponsors a prestigious string competition yearly. Dworkin won the MacArthur Genius Award for his work. (Courtesy of Bev Willis.)

Helen Oliver is founder of the African American Saturday Academy. An unidentified student is seen working at the computer. The academy was unique because it was community-based and community-developed. This was important to students and parents who often felt they did not have a voice. The goal of the academy was to increase the number of students in math and science using computer-based training, and to strengthen parental support. The academy participated in a Computer Challenge Club that engaged students in computer skill–building activities. The program introduced students to web design, video production, and animation. Since its inception in 1989, 2,500 students and parents have participated in the academy. (Courtesy of Another Ann Arbor, Inc.)

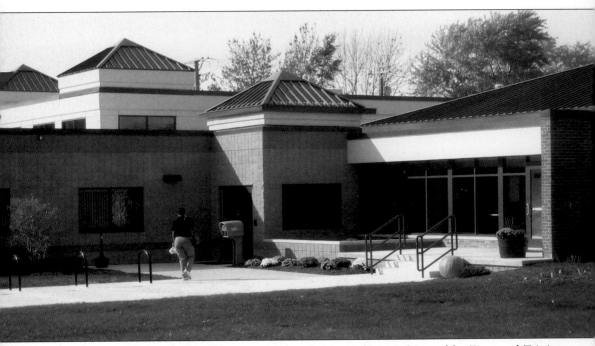

The Peace Neighborhood Center was built in 2003 on property donated by Zion and Trinity Lutheran Churches. A large opening celebration welcomed the public to the new facility. City officials and representatives of various organizations attended. The first Peace Neighborhood Center was formed in 1971 when tensions arose between tenants in the new public housing complex and private homeowners in the North Maple neighborhood. The two Lutheran churches provided use of a building at 111 North Maple Road, where neighbors could meet. Rose Marin, a community advocate, spearheaded a program of after school activities there for children and their families. As the services grew, Peace became a United Way Agency. Summer day camp, tutoring, mentoring, and family support services were added. Through private donations, grants, a large number of volunteers, and a devoted staff, the program has met with success. (Courtesy of Another Ann Arbor, Inc.)

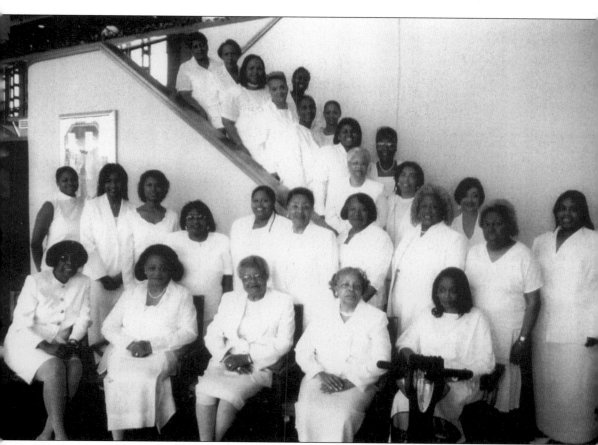

The Delta Psi Omega chapter of Alpha Kappa Alpha sorority was chartered on December 4, 1948, at the "B" house dormitory on Catherine Street in Ann Arbor. Charter members of the chapter were Roberta Ellis Britt, Edyth Bryant Cole, Dorothy Cook, Margaret "Margo" Bryant Ellis, Gertrude Francois Warren, Geraldine Jefferson, Marie Blanche Penn, Dorothy Hawkins Smith, Toledo Snyder, Catherine Roberts Williams, and Yvonne Williams. Today the signature program of the chapter is a fashion show luncheon, which raises funds to provide scholarships for area students. The chapter also sponsors A Celebration of Black Men, which recognizes men who are making contributions to the community. The chapter cosponsors Take our Daughters to Work, a program that encourages young women to examine various career possibilities. (Courtesy of Delta Psi Omega Chapter of Alpha Kappa Alpha Sorority, Inc.)

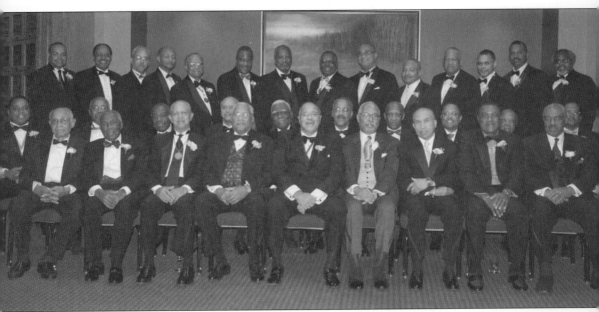

Gamma Rho Boule is the Ann Arbor chapter of Sigma Pi Phi fraternity. The chapter was founded on January 17, 1987, on the campus of the University of Michigan by Henry Johnson, attorney Fredrick McDonald Sr., attorney Fulton Eaglin, and Harold Fowler. Since its inception, the Boule has grown from 18 to 40 members. The Boule has focused on developing innovative programs to encourage excellence in African American middle school students. In addition, the chapter has created a speakers bureau that offers lectures on topics of concern to African Americans in the Ann Arbor area. However, the main focus is on "getting to know the best of one another and to enhance and empower excellence in all endeavors." The chapter holds a holiday brunch annually for members and their guests. (Courtesy of Gamma Rho Boule Chapter of the Sigma Pi Phi Fraternity.)

The Ann Arbor chapter of the National Association of Negro Business and Professional Women's Clubs Inc. was chartered in 1976. Their mission is to advocate, educate, and cooperate in and implement programs relative to matters affecting African American women and society. Pictured in the front row are, from left to right, Juanita King-Batie, Bettye McDonald, and Pres. Joyce Adams. In the back row are, from left to right, Vivian Hawkins, district governor Gail Quann, and Elinda Burks. (Courtesy of Ann Arbor Chapter of The National Association of Negro Business and Professional Women's Club, Inc.)

The Ann Arbor/Ypsilanti chapter of Mocha Moms was founded in January 2004. The chapter is part of a national organization whose purpose is to provide support for women of color who have chosen not to work full-time outside of the home. They strive to provide each other with help in becoming better mothers and allowing their children to build relationships with other children of color. The chapter service project is to educate women about heart disease. (Courtesy of Ann Arbor/ Ypsilanti Chapter of Mocha Moms.)

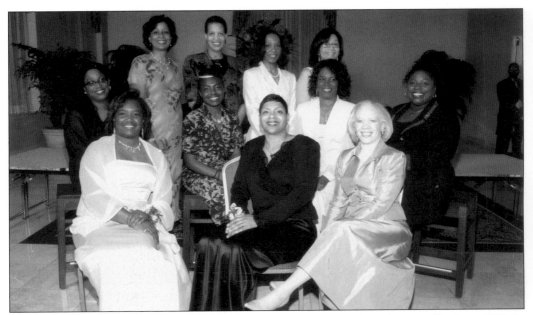

Presented here are some of the current members of the Ann Arbor chapter of Jack and Jill. In March 1976, the founders, Lola Jones and Barbara Robinson, invited several interested mothers to discuss forming an Ann Arbor chapter. An interest group was created in 1977 and given provisional status for a year. The chapter was officially installed in September 1978 with Barbara Robinson as its first president. From left to right are (first row) Desiree Blake, Stephanie Jones, and Gayle Martin; (second row) Gail Smith, Janice Amin, Eula Eaddy, and Dorian Moore; (third row) Monique Washington, Fayth King, Donna Bowen, and Marina Shoemaker. (Courtesy of Jack and Jill Inc, Ann Arbor Chapter.)

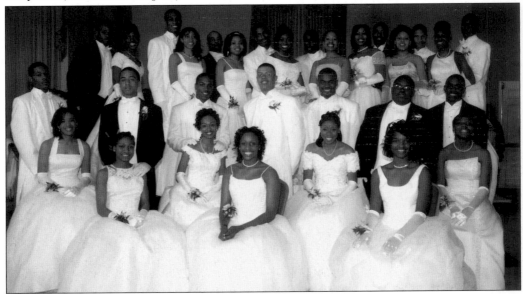

In April 1979, the Jack and Jill Chapter of Ann Arbor held its first Beaux-Debutante Ball. The ball was a first of its kind as the chapter decided to honor male graduates as well as the debutantes. It has become a signature program for the Ann Arbor chapter for over 25 years. The beaux and debutantes pictured here are from the 2005 ball. (Courtesy of Jack and Jill, Inc., Ann Arbor Chapter.)

Cotillions are dances that introduce young women and men to society. Students are taught elaborate dances whose roots date back to the West Indies of the 1800s. Couples are shown the proper way to bow or curtsey. Cotillions seek to develop self-assurance, civility, and politeness in their youthful participants. Sometimes college scholarships are awarded to the graduating seniors. The region's L'Esprit Club hosted these Debutante Ball cotillions for many years. (Courtesy of Robert Hunter.)

The Ypsilanti/Ann Arbor area L'Esprit Club hosted the Debutante Balls or cotillions for many years. Their last ball was in 1973. The Jack and Jill Beaux Debutantes' Ball began in 1979. University of Michigan dance professor Vera Embree choreographed their complex dances, which included a father-daughter, mother-son sequence and featured dips and turns where a beau would lean his debutante almost into a back bend. (Courtesy of Jack and Jill, Inc., Ann Arbor Chapter.)

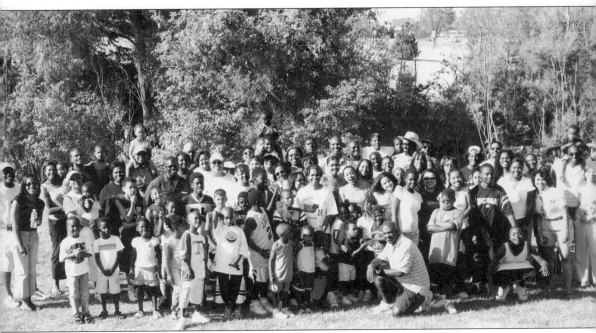

Pictured here is a gathering of the Ypsilanti Jack and Jill Families on a Sunday afternoon outing. The number of families gathered here is testimony to its vibrancy. In September 1985, the Ypsilanti chapter of Jack and Jill was organized by Dr. Jan Collins Eaglin and Tracey Brown White, with the interest of Dr. Kenneth Hick. The trio believed that tangible goals could be reached through unity of purpose with those of similar interests and aspirations. The organization was chartered in November 1989, with the following charter members: Francetta Ampey, Gwendolyn Clark Sills, Jan Collins-Eaglin, Maynette Dolberry, Rosalyn Erby, Geraldine Ford-Brown, Vivian Hawkins, Debbie McClease, Ethel Patton, Alice Peoples, Beverly Pettigrew-Hicks, Georgianna Purnell, Wilma Ratcliff, Juanita H. Reid, Pat Roberson, Cassandra M. Russell, Cynthia Sidney, Cheryl Sims, Katie H. Smith, Beverly Tyler, Eva Warren, Laval Weathers, Tracey Brown White, and Theresa Wilson. (Courtesy of Jack and Jill, Inc., Ypsilanti Chapter.)

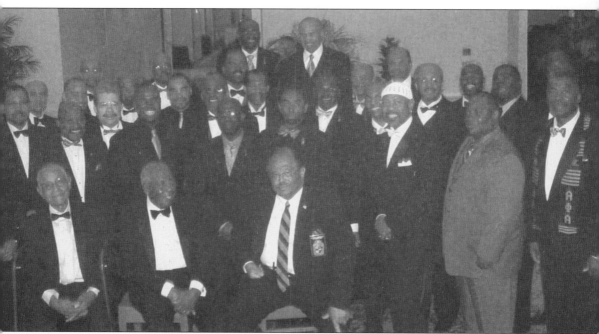

The graduate chapter of Alpha Phi Alpha Fraternity Inc. in Ann Arbor, Theta Zeta Lambda, was founded on January 21, 1962. Founding members were Rev. Lyman Parks, John L. Ragland, John Mansfield, Dr. Thomas Bass, Rollin P. Greene, Booker Brooks, and Dr. Henry C. Bryant. The founding members were soon joined by Dr. Watson A. Young, James W. Neal, O. Herbert Ellis, Gordon Martin, David Byrd, and James W. Anderson. The chapter holds a "Go to High School/Go to College" scholarship luncheon annually where awards are made for academic improvement. In 2004, the chapter was recognized for being a leading contributor to the Martin Luther King Jr. Memorial Project. The chapter holds a scholarship luncheon annually where awards are made for academic improvement. Members conduct a mentoring program for young men as well. (Courtesy of the graduate chapter of Alpha Phi Alpha Fraternity Inc, in Ann Arbor, Theta Zeta Lambda.)

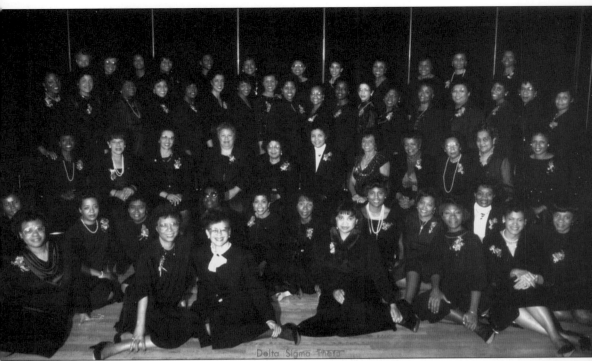

Pictured are members of the Ann Arbor Alumnae Chapter of Delta Sigma Theta Sorority, Inc. The group was chartered by 23 members on November 17, 1962. The chapter has been serving the interests of Ann Arbor and Ypsilanti for the past 42 years through scholarships and other public service activities. Contributing to the Peace Neighborhood Center is just one instance of community support. The chapter has maintained continuity in their commitment to educational and economical development, physical and mental health, international awareness and involvement, and political awareness and involvement. The chapter's K-8 Science and Everyday Experiences program to develop and conduct informal science education activities is an example of a service project. Service is inclusive, as evidenced in the chapter's commitment to work cooperatively in various projects with community agencies, organizations, and other sisters and brothers in Greek organizations. (Courtesy of Ann Arbor Alumnae Chapter of Delta Sigma Theta Sorority, Inc.)

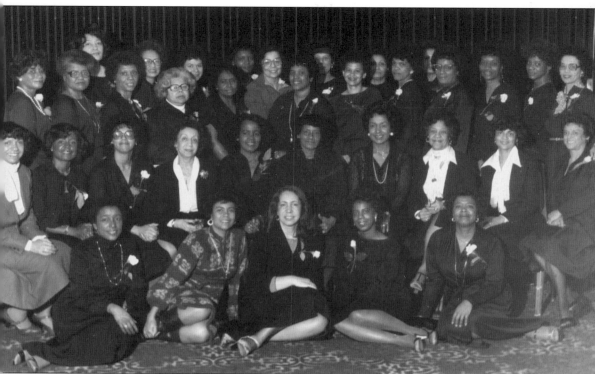

The Ann Arbor chapter of the Links, Inc. was organized by Virginia Ellis, who became its first president. The name Links was adopted to express the experience of each woman becoming a link in a chain of friendship. The organization promotes programs in the arts, national trends, international trends, and services to youth. The mission is to serve the community within the four facets of the club. The chapter holds an Elegant Evening fund-raiser to benefit various service projects. Charter members are Delores Anderson, Virginia Bailey, Gwendolyn Baker, Sadie Blackwell, Carolyn Boyd, Juanita Bradley, Letitia Byrd, Burnita Cash, Betty Jean Childress, Ila Edwards, Virginia Ellis, Rose Gibson, Christina Gilchist, Mary Hamilton, Gloria Horne, Lola Jones, Anne Lucas, Bettye McDonald, Shirley Martin, Barbara Meadows, Christella Moody, Christina Neal, Josephine Owens, Henri Parker, Jennie Partee, Zerilda Palmer, Hazel Turner, Frances Vaughn, Rebecca Vaughn, Frances Watts, and Rosetta Wingo. (Courtesy of Shirley Martin.)

The David Byrd Center is an 1840s farmhouse restored by Ann Arbor architect David R. Byrd. The center, located at 3261 Lohr Road, has been designated a historic building. It is used as a meeting place for community organizations and events. The African American Cultural and Historical Museum is housed there. Byrd designed the chapel at New Covenant Missionary Baptist Church in Ypsilanti, and the Episcopal Church of the Incarnation. (Courtesy of Letitia Byrd.)

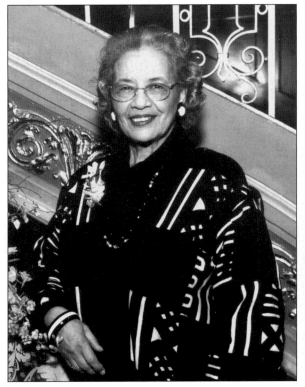

In 1997, Letitia Byrd was selected as Ann Arbor's first "Citizen of the Year" by the *Ann Arbor News*. Letitia serves on over 35 boards and organizations. Among these are the S.O.S. Crisis Center, Ronald McDonald House, African American Endowment Fund, and African American Cultural and Historical Museum, to name just a few. She serves actively in each organization. (Courtesy of Letitia Byrd.)

Exemplar Manufacturing Company on Harriet Street in Ypsilanti became one of the state's largest black-owned automotive part makers and a key supplier to Ford Motor Company and General Motors Corporation. Anthony Snoddy, a former GM official, employed 200 workers here and operated a plant in Mexico. (Courtesy of Another Ann Arbor, Inc.)

The sign at the office of Dr. Craig Shelton has been a fixture at this location for almost 40 years. Dr. John Shelton opened his practice here in the late 1960s and retired in 1994. His son, podiatrist Craig Shelton, occupies the space and carries on the health care tradition. The first block of Ferris Street has been renamed Shelton Street in honor of John Shelton. (Courtesy of Another Ann Arbor Inc.)

Jim Bradley opened the Jim Bradley Pontiac, Cadillac, GMC dealership in 1973. His was the first African American–owned dealership in Washtenaw County. A graduate of Michigan State University, Jim spent 10 years on GM's corporate side, then received training at GM's dealership school. The Bradley Automotive Group was a fixture in *Black Enterprise* magazine. Bradley won the National Association of Minority Auto Dealers Trail Blazer Award in 1996. Nicknamed the "Godfather," Bradley generously mentored many. In 1993, his wife, Juanita Bradley, opened Saturn of Ann Arbor on Jackson Road. Jim Bradley died suddenly in 2003. The business was sold to Jim Allen, and it remains the nation's longest-standing black-owned GM dealership. The Saturn dealership was sold to Mack Johnson and continues to be minority owned. (Courtesy of Another Ann Arbor, Inc., and the Bradley family.)

Dr. James Lee opened the Family and Cosmetic Dentistry Office at 1157 Packard Road in Ann Arbor in July 1998. He has been in private practice for 16 years. Lee began the tradition of providing free oral health care services to the uninsured and underserved on the Martin Luther King holiday. He does this to honor King's legacy. (Courtesy of Another Ann Arbor, Inc.)

This familiar sign, Illi's Auto Service, has been in place at 401 West Huron Street since 1948. The new owner, Larry Young, was employed there for eight years as an automotive technician and later as assistant manager. In 2002, when the owner retired, Young purchased the business. (Courtesy of Another Ann Arbor, Inc.)

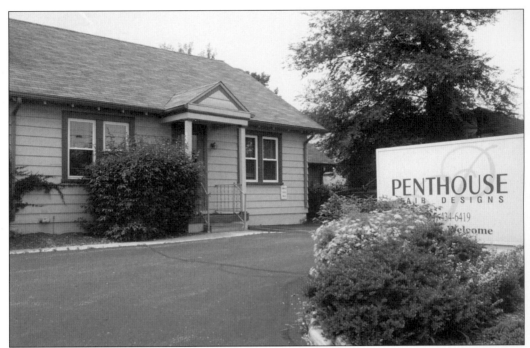

Penthouse Hair Designs, owned by Premail and Patricia Freeman, has been located at 561 North Hewitt Road in Ypsilanti since 1998. The name was derived from its first location on the top floor of a building in downtown Ann Arbor. (Courtesy of Another Ann Arbor, Inc.)

Johnnie Rush's Barbershop, located at 1031 Broadway Street, has been a landmark for 46 years. Rush came to Ann Arbor in 1946 as a teenager. He graduated from Pioneer High School and Michigan Normal School. After a stint in the service in 1954, he returned to Ann Arbor. He decided to become a barber because he wanted to own his own business. (Courtesy of Another Ann Arbor, Inc.)

Cannon's Warehouse fills the corner of Hamilton and Harriet Streets, where it has been located since 1979. Gregory Cannon came to Ypsilanti hoping to find a job at the automobile plant. When that effort failed, he went to a warehouse, bought $100 worth of items, and set up a small shop right at this location. He has been in business ever since. (Courtesy of Another Ann Arbor, Inc.)

Puffer Red's is located at 113 West Michigan Avenue in downtown Ypsilanti. The store name comes from a childhood nickname of the owner. In 1974, when he was just 17 years old, Eric Williams decided to start a small music store with cassette tapes and hip music. He then added t-shirts, designer jeans, and other items that appeal to male youths. Today Eric and Tandra Williams have expanded the store into an entire block. (Courtesy of Another Ann Arbor, Inc.)

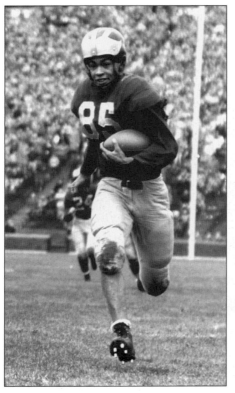

Lowell Perry Jr., son of Dr. Lowell Perry of Ypsilanti, was one of the University of Michigan's greatest ball catchers. He played football from 1949 to 1952. He was named an All-American end in his junior year. Later he played for the Pittsburgh Steelers until he suffered a career-ending injury. As with a few special athletes, Perry is well remembered off the field as well. In 1966, he was the nation's first black television sportscaster. Perry earned his law degree in 1973 and became Chrysler's first black automobile plant manager. He chaired the federal Equal Employment Opportunity Commission and Michigan's department of labor. Perry retired after 40 years of accomplishment. (Courtesy of University Of Michigan, Athletic Department.)

Don Deskins Jr. is professor emeritus of urban geography and sociology. He is a former University of Michigan tackle (1958–1959) and an NFL first-round draft pick. He earned his bachelor's degree, master's degree, and doctorate in geography from the University of Michigan and played for the Oakland Raiders in 1960. Deskins joined the faculty in 1982 as a professor of urban geography and sociology. He has received many awards, including the Distinguished Faculty Governance Award, the Faculty Recognition Award, the Harold R. Johnson Diversity Service Award, and the Charles D. Moody Sr. Higher Achievement Award. The Bates-Deskins student-athlete award is named in his honor. Deskins is a Fulbright scholar and has researched issues on race, ethnicity, inequality, poverty, and conflict in cities. (Courtesy of University Of Michigan, Athletic Department and Bentley Historical Library.)

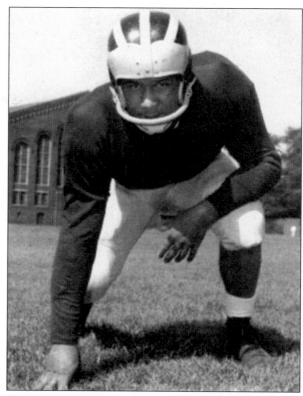

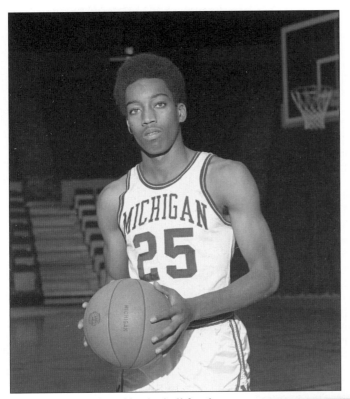

Richard Carter played basketball for the
University of Michigan in 1969 and 1970.
After he graduated and finished college
athletics, Carter began giving back to
the university and to minority students
in particular. He was assistant director
of the Alumni Association and served
as an associate dean for Student Affairs-
Multiculturalism. In 1998, Carter received
the Exemplar Award from the Association of
Black Professionals, administrators, faculty,
and staff. Currently Carter is an associate
director of the State Outreach Office in the
vice president's Office for Governmental
Relations. As a state and community
relations officer, Carter meets with
community leaders from around Michigan.
He maintains communication between
the university and communities statewide.
(Courtesy of University Of Michigan,
Athletic Department/ Richard Carter.)

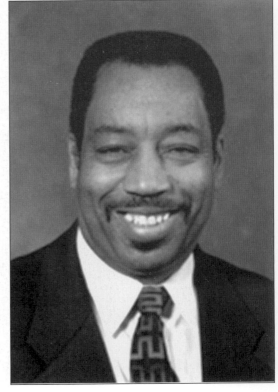

Thomas Goss was the University of Michigan's first African American athletic director from 1997 to 2000. He oversaw the university's 23 varsity coaches and teams, the athletic fields and facilities, and a multimillion dollar departmental budget. Goss began his career at the university on the football team as a tackle from 1964 to 1968 and won All-Conference awards. He received his bachelor of science degree and became a successful sales executive with major corporations while serving on university committees and in alumni associations around the country. He received the Distinguished Alumni Service Award in 2001. Goss went into business, founding the Goss Group, Inc. He was appointed to the African American Experience Fund of the National Parks Service and Foundation and has chaired the mayor's Detroit Workforce Development Board. (Courtesy of Bev Willis.)

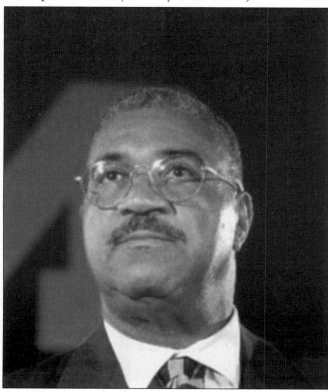

In 1972, Dr. Willie Hobbs Moore became the first African American woman in the United States to receive a doctorate in physics, according to the University of Michigan department of physics. After her doctorate, she continued researching biological molecules at the university. Later in her career at the Ford Motor Company, she worked on improving the reliability of engineering and manufacturing processes. Despite her arduous studies and work responsibilities, Moore always made time for family, friends, and community service. She was an active member of Jack and Jill Inc., a member of Delta Sigma Theta sorority, and the Links, Inc. Her humor and laughter were a part of many social occasions, and she regularly tutored students in her home. One of her final tasks was researching and writing an updated history of Bethel AME Church. She died after a long illness. (Courtesy of Sidney Moore.)

Maria and Levi Thompson founded T/J Technologies in 1991. They are an award-winning, Ann Arbor–based, research and development company specializing in the production of alternative energy products on the nanometer scale. They develop batteries, fuel cells, and other materials for NASA and commercial concerns. They have won awards from Michigan's Small Business Association and *Black Enterprise* magazine, as well as NASA. Maria is the president and CEO. She has her bachelor's degree in industrial design. Her MBA is from the University of Michigan. Dr. Levi Thompson is the company's chief technology officer. His work is patented. He is the Richard E. Balzhiser professor of chemical engineering and associate dean of undergraduate education for the college of engineering. His bachelor's degree in chemical engineering is from the University of Delaware. His master's degrees are in chemical engineering and nuclear engineering, and his doctorate is in chemical engineering, all from the University of Michigan.

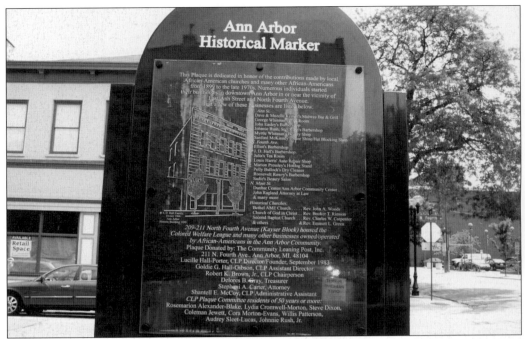

This historic marker was installed on June 3, 2006, by the city of Ann Arbor. The plaque honors the contributions made by local African American churches and businesses from 1899 through the 1970s. Historically black businesses have existed on Ann Street, South Fourth Avenue, and North Main Street. (Courtesy of Another Ann Arbor, Inc.)

In 1997, the University of Michigan Law School was sued over its admissions policies. The case, along with a companion suit against the undergraduate school's policies, was heard before the U.S. Supreme Court. On June 23, 2003, in a major victory for the law school, the court upheld the right of universities to consider race in admission policies. Its impact is considered precedent-setting. (Courtesy of Another Ann Arbor, Inc.)

Homer Neal served as interim president of the University of Michigan in 1996 and 1997. During his tenure, he reinforced the university's commitment to diversity, helped to redefine the nature of government-university research partnerships, expanded undergraduate research opportunities, supervised the medical center's reorganization, and improved communication throughout the university. Neal grew up in southern Kentucky where an interest in shortwave radios led to a love of science. He received his bachelor of science degree in physics, with honors, from Indiana University and his graduate degrees from the University of Michigan. Neal was vice president for research and chair of the physics department, as well as an Alfred P. Sloan fellow, a John Guggenheim fellow, and a fellow of the American Association for the Advancement of Science. Neal conducts research at CERN, the largest laboratory for particle physics. He is director of the university's ATLAS Project, a collaborative particle physics experiment, and continues as the Samuel A. Goudsmit professor of physics. (Courtesy of University of Michigan Photo Services.)